PEGASUS
Library

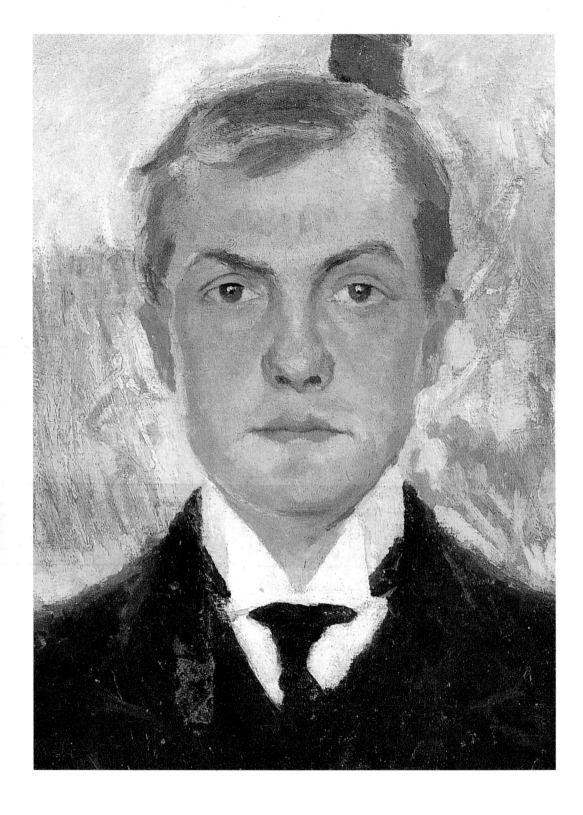

Sister Wendy Beckett

Max Beckmann
and
The Self

Prestel

Munich · Berlin · London · New York

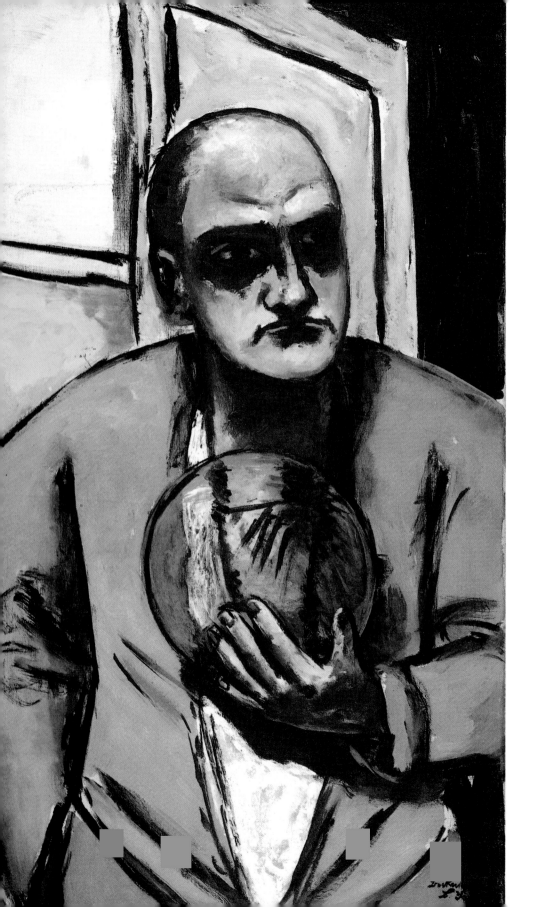

Contents

*"If you wish to get hold of the invisible,
you must penetrate as deeply as possible
into the visible"*

Max Beckmann is a mysterious artist, almost hermetic.
This is not because his work is, in itself, 'difficult' (though
his symbolism often needs interpretation), but because
what he painted is always weighty with some unseen
significance. He spoke of his 'goal' as being 'transcen-
dental objectivity',[1] to show both what is there and what
is implied spiritually, without becoming pretentious, self-
conscious or, indeed, obvious. His is a superb balancing
act, addressing what we are metaphysically rather than
what we understand objectively, but using our intellectual
insight to draw us into this deeper understanding of
'significance'.

 Take one of Beckmann's simplest pictures, *Girl with
Yellow Cat (on Grey)*. It may well be a realistic portrayal of
a young woman; dedicated ailurophiles will feel, however,
that the cat is weirdly vulpine, almost as quick, sinister and
cunning as foxes are fabled to be. Yet, the orange, sharp-
muzzled cat, pawing affectionately at the girl's neckline,
is an eerie parallel to the girl herself. That long wedge of
a nose, that suspicious sideways glance of the eye observ-
ing us in secret: both are disturbing. The girl's skin has a
bluish pallor; her dishevelled cap of hair has a metallic
glitter, aggressive yellow flared with green and blue; her
large and boneless fingers clutch defensively at both her
pet and her own bosom. Against the deep purple of her
dress, her fingernails seem predatory. And her setting?
There is only a greyness, deepening and thickening behind
her head, with the red of her nails repeated in some object
below (a sofa, perhaps) and the yellow of her hair matched

Girl with Yellow Cat (on Grey),
1937

by the shape at the far left (a cushion on the putative sofa?). We begin to feel that the strips of banded yellow on her neck and sleeve and the red and white bracelet round her wrist are there to constrain her, to tie her into the painting. We vacillate in our reaction, feeling that the girl is ominous, hostile or defensive, sphinx-like. This is an electric painting. Although totally lacking in the *Mona Lisa*'s self-confidence and angelic complacency, it does suggest something of her enigmatic quality.

That a painting as apparently simple as this should give us so much to question (in fact, to discomfort and

challenge us) is the result of Beckmann's unwavering search, in all he painted, for 'the Self'. It is not that he distorted, but that he could only see through the eyes of his own uniqueness, his intense individuality. When he went to America to teach towards the end of his life, he told his class in St Louis, 'If you want to reproduce an object, two elements are required: first, the identification with the object must be perfect, and secondly, it should contain, in addition, something quite different ... In fact, it is this element of our own self that we are all in search of'.[2] This is an amazing statement. It encompasses two extremes. The artist is to identify 'perfectly' with the object, subdue himself or herself absolutely, so that the object can impose its own reality. But equally, the artist must express in the object something of the self, that almost mystical truth that is personal to each individual and that is never easily grasped or even achieved. We are 'in search' of our truth all our lives. In a letter to a close friend, Stephan Lackner, Beckmann wrote about this search, 'What it's all about is: the permanent, the unique, the true existence all through the flight of illusions, the retreat from the whirl of shadows'. He added wistfully, 'Perhaps we will succeed in this'.[3] In his diary, he described the ego as 'dark, strange, estranged, and closed-off from itself'.[4] When we look at a work by Beckmann, this is what we are in contact with: something objectively achieved, marvellously so, but also the painter's painful struggle to find the truth of his own ego, to open it up, to discover its meaning and thereby set us free to encounter our own. Since we may be unconsciously resistant to this process, every Beckmann painting is a profound challenge.

It is no surprise, given this hidden agenda, that Beckmann was second only to Rembrandt in his interest in self-portraits. There are very few artists who have not painted a self-portrait or two, mostly in a valedictory spirit, as a

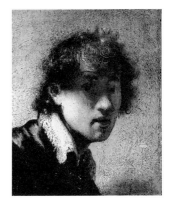

Rembrandt, *Self-Portrait*, 1629

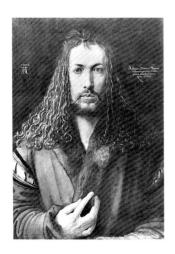

Albrecht Dürer, *Self-Portrait,*
1500

sort of imaged signature. Sometimes, there is clearly the motive of vanity. Dürer's greatest works could arguably be his two magnificent self-portraits, in which every last detail of his own extraordinary beauty is passionately delineated for the admiration of the viewer. Such narcissistic intensity carries within it its own terminus: Dürer had no need to repeat his efforts. But for Rembrandt, as for Beckmann, studying his own likeness was a lifetime's occupation, pursued not for pleasure but out of interest. Rembrandt is above all the portraitist of the soul: where other artists such as Holbein or Ingres can show us with more delicate precision what sitters looked like, Rembrandt's concern is what they were like within. He delves beneath; he conveys the spiritual scent, as it were. But when it came to himself, Rembrandt was uninterested in his inner being. He was, in fact, disinterested, regarding that squat peasant face with scientific detachment. He was intent only on showing what he, that morning, that misty evening, in his small studio, actually saw. We could write a biography of some painters – Picasso, for example – from their paintings; Rembrandt kept his life's adventures private.

The same is true of Beckmann. He can bring us close to a sitter, as he does in *Portrait of Fridel Battenberg,* 1920 (p. 10), or, for that matter, in *The Girl with Yellow Cat (on Grey),* 1937, but he has little of the touching power of Rembrandt, that astonishing ability to make us aware of what his friends and patrons felt in their hearts. Yet, although Beckmann did at least eighty self-portraits, just a few short of Rembrandt, he too was wholly without vanity. Rather, he painted himself as if thereby to find himself. If he could make visible, he seemed to feel, these lineaments, that expression, that visual record of his experience, then he might come to a deeper understanding of what he was. There is an urgency we do not find in

9

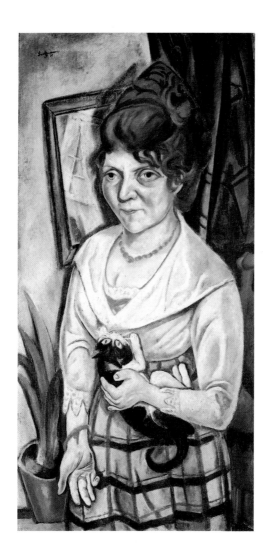

*Portrait of
Fridel
Battenberg,*
1920

Rembrandt, a seriousness that some might call typically
Teutonic. If Beckmann rarely laughs in these works, it is
because this is no laughing matter. If Rembrandt moves us
with his insight, Beckmann moves us with his earnestness.
It matters so much to him, and he has only his skill to
depend on.

"To find one's 'self' is the driving force behind all characterless souls"

Unlike some painters of genius, who have arduously to acquire their skills (we think of Cézanne or Matisse), Max Beckmann's natural skills were evident from a young age. He was born in Leipzig in 1884, the youngest child of a prosperous miller, grain merchant and laboratory experimenter. Carl Beckmann died when Max was ten. The boy seems to have dominated his mother, running away from boarding school and spending his class time painting. He hated, then and later, any enforced constraints. 'I excelled in school', he reminisced, 'by running a little picture factory, whose products … consoled many a poor fellow slave.'[5] He was determined at sixteen to become an artist, and the well-meaning attempts of his guardian to make him finish his academic course were routed by the boy's intense determination to have his way. It is easy to see why he won his case: almost his first surviving work, significantly a self-portrait, is dated c. 1898–1900, when he was about fifteen (*Self-Portrait with Soap Bubbles*, p. 12). It is an unsparing portrait, with little adolescent defensiveness. He did not glamorise away his massive, almost prognathous chin, a physical feature that was to draw unflattering comments all his life. The young Beckmann leans back in his chair, rapt, gazing not at the widespread landscape, with its fringed curtain of lowering cloud, but at his own production, the soap bubbles of his private world. Even at this early stage, he alarms us. The face of the youthful artist is frightening, too avid, too undefended. Later, he will learn the necessity of masks, but in his teens, as yet untaught, he abandons himself almost orgiastically

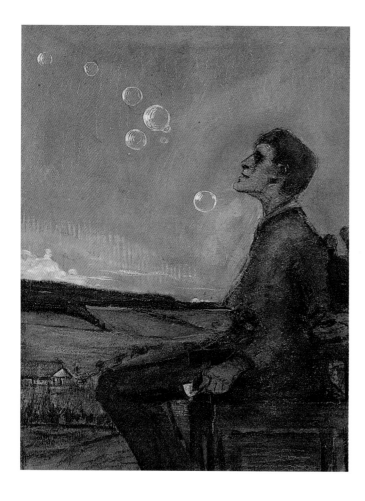

Self-Portrait with Soap Bubbles,
1898–1900

to the intoxication of creation. There may be irony, too.
Soap bubbles are a familiar symbol of transience, of pride
confounded. Beckmann may well have been staking his
all on his claim to creativity while admitting with a self-
deprecatory sigh, that no human work is everlasting. Even
at this early stage, before Beckmann becomes Beckmann,
we find this intriguing hint of duality, one the mature
artist would explore to its depths.

This early self-portrait is dull tonally; Beckmann's
original interest seems to have been far more in line than
in colour. Between 1900, when he was sixteen, and his

coming of age, there are three startling self-portraits, all in dry-point or pencil. At seventeen, he produced *Self-Portrait,* 1901 (p. 15), an etching that demonstrates that he had come to know and admire the early Rembrandt. Rembrandt too had begun his career by making faces at himself and etching them. The interest is all in the expression, the grimace. Beckmann is screaming, either with mirth or with wrath, or with an extremity of pain, and the art is in his skill. We are as unmoved as by the young Rembrandt's grimaces, but we admire the skill that captured the tension of the cheeks and the furrowed brow.

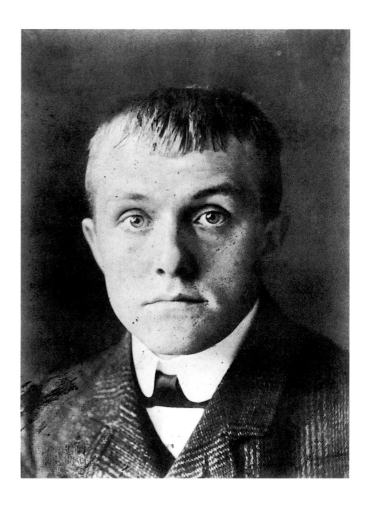

Photograph of Beckmann, aged 23

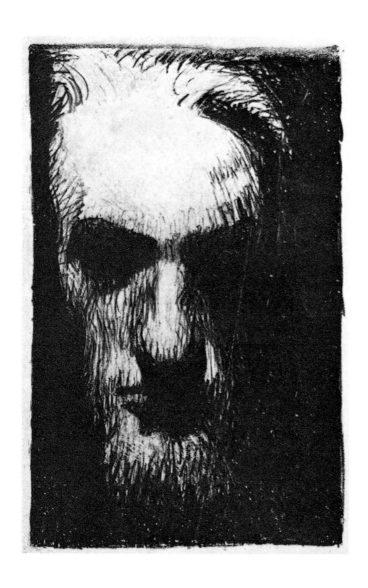

Self-Portrait with Beard, c. 1903

Facing page: *Self-Portrait,* 1901

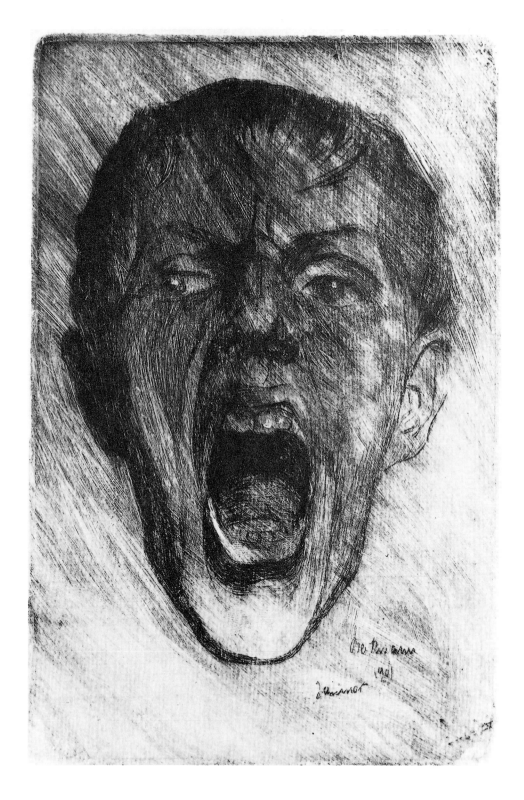

Without the title of *Self-Portrait,* we could not identify the sitter, however. The earliest photograph of Beckmann as a young adult, taken in 1907 (p. 13), shows a massive hulk of a youth, intent upon his easel, physically mature beyond his years. But it is recognisably the same Beckmann that we are to see throughout the years ahead, with his large, pale and somewhat frozen-looking face. A friend once described his features as being rather rough, like a 'sad bulldog' and emphasized the unusual proportions of his head. The artist seems to have become massive early in life, but just as one could not recognise him from the 1901 self-portrait, one could also not do so in the bizarre lithograph of some two years later, *Self-Portrait with Beard,* c. 1903 (p. 14). What makes this print unmistakably Beckmann's is not its unsettling power, but the impenetrably hooded eyes that confront us could as well be those of the suffering Christ as of the adolescent artist. Its great interest, in considering Beckmann's quest for the Self, is its masked quality. The big nose juts down, shadowing the mouth, always a give-away feature of a face. As in the earlier print, there is no neck, no body: in fact, all his life Beckmann feared the body and the tyranny of the senses. He understood sensuality, as his work makes abundantly plain, but it had to be controlled. He would write about 'this horribly convulsing monster of vitality', and his cold determination to 'get my hands on it … and cage it up in sharp lines and surfaces'.[6] *Self-Portrait with Beard* reveals this early fear: he has lost 'himself' in the actuality of the work, in its facture. He has divorced his real face – and still more his real body – from his achievement. He has escaped, something he would learn not to do so explicitly.

In the same year, we can see him escaping again, this time far more credibly. *Self-Portrait with Straw Hat* is instantly recognisable, with visible torso and slightly cosmeticised features. But it is Beckmann as 'young toff',

Self-Portrait with Straw Hat, 1903

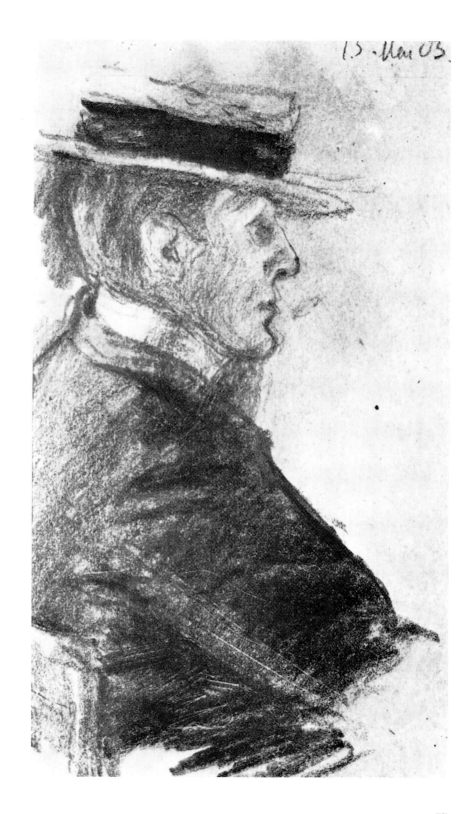

13. Mai 03.

17

a disguise especially dear to him. It crops up all his life, though never as charmingly as here. Seen from the right angle, that great craggy face could appear quite hand-some, though the lips are steely and the jaw remains indomitable. The arrogant tilt of the hat is very typical: Beckmann was a natty dresser, however incongruous that might seem to us. His clothes, though, were part of the armour with which he faced the world. A print from the year he turned twenty, *Self-Portrait*, 1904, pours its only strength into his bow tie and black suit. The actual face is hesitantly depicted, half lost in the whiteness of the page.

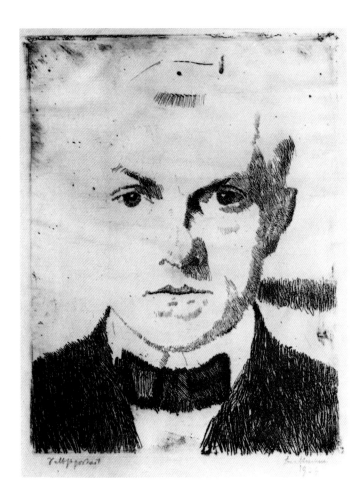

Self-Portrait, 1904

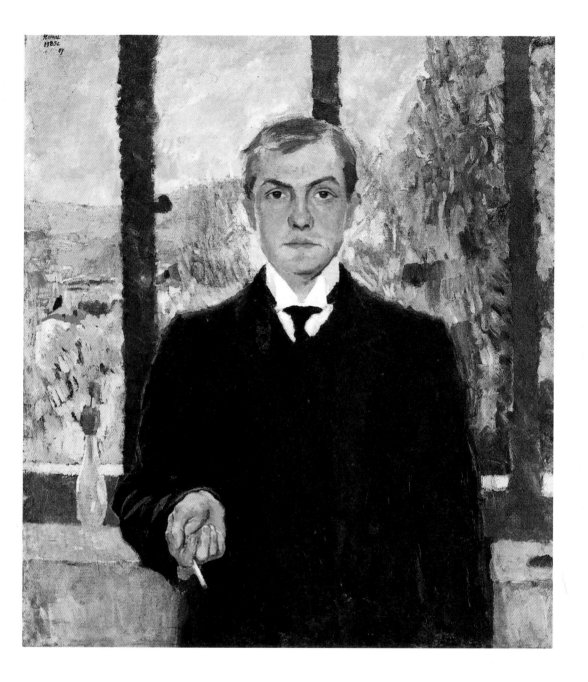

Self-Portrait in Florence, 1907

Beckmann confronts us squarely, but he does not meet our gaze. His eyes seem to look inwards, as the portrait fades into brightness. For all this seeming hesitation, though, it is a remarkably assured picture, and in this sense it is indicative of what was happening to the artist in the outside world.

He had become a success. Critics were paying attention; he was soon to win a scholarship to Florence, and before he was thirty there would be a monograph published about his work. He was young when he first married, to a beautiful and supportive artist, and his first self-portrait in oils shows him triumphant with recognition and achievement: *Self-Portrait in Florence*, 1907 (p. 19). He is dressed as a gentleman, casually holding a cigarette, staring out with complete self-assurance. He is not, however, disagreeably self-confident, just in command of himself and his destiny, at home in society. What makes this picture especially interesting is the mixture of painting styles. Behind Beckmann is Florence; the great Renaissance city shimmers and floats in a daze of impressionistic colour. Even the bars at the windows, which might seem to shut him off from the city, waver and sway, lacking solidity. The wall behind his back, the vase at his side – these, too, are not wholly real, not objectively powerful. But Beckmann himself is not painted with impressionistic flutter. He is toughly present, from his strong pink face to the clutching hand with its cigarette. It is as if he cannot bear to let himself slip, to trust himself to the light as he happily entrusts the external world. Implicitly, he makes an aesthetic contrast between the potential that life offers – the conquest of all that Florence symbolises – and the reality of what he himself has become. He is a density of black suit and healthy pink flesh, and all else is relatively insubstantial. The wry acceptance of what he is not saves the work from arrogance. He is not, or not yet, at home in

Photograph of Beckmann in Florence, 1906 (Photo: Alinari)

the Florence of Michelangelo or Leonardo. But he has taken stock and positioned himself.

This is a graceful admission of ambition, and the next few years see that ambition in action. The young Beckmann – this is a painter still not thirty – turned to heroic themes, to depicting great disasters, like the earthquake at Messina or the wreck of the *Titanic* (pp. 22–23), huge canvases of immense complexity and animation. They were, in fact, themes too advanced for him to comprehend as a man or cope with as an artist, but he struggled. What drew him to these dark and difficult subjects? When he read of the destruction of Messina, where 80,000 of its 120,000 inhabitants were destroyed, he wrestled in his diary with the source of his fascination:

> I want space, space. Depth, naturalness. As far as possible no violence. And austere colours … The pallor of an atmospheric storm and yet all of our pulsating sensual life. A new, still richer variation of violet red and pallid yellow gold. Something rustling and rank like a lot of silk that one peels apart, and wild gruesome glorious life.[7]

What came of this fascination is a disturbing picture, pervasively immature. Despite this intended refusal of violence, all he painted is conflict and agony, a brutalised scene of human savagery. It is gruesome enough, but we look in vain for the glory. Beckmann seems to have thought that he could remake reality at will, recasting a natural disaster on his own terms. The buildings stand; the humans attack one another. The picture is lurid and austere in colour; we feel that Beckmann essentially was seeking to exorcise something within himself, using this tragedy as a means. The sense of manipulation is distasteful. The destruction of Messina seen as a way towards the artist's self-fulfilment: this was a mistake he grew to recognise and abjure.

What this unpleasant picture does is highlight Beck-mann's propensity for egocentricity, something every artist, every person, must face and combat. The artist must make visible to us a vision, his or her own, but it will be diminished by the encroachments of selfishness. There must always be that 'perfect identification' with the exter-nal about which Beckmann himself spoke to his students, before the vision can be wholly infused with the search for the Self. Beckmann was about to learn this lesson as few others have done. Five years after this painting came the Great War.

Beckmann in front of the painting *Sinking of the Titanic,* 1912–13

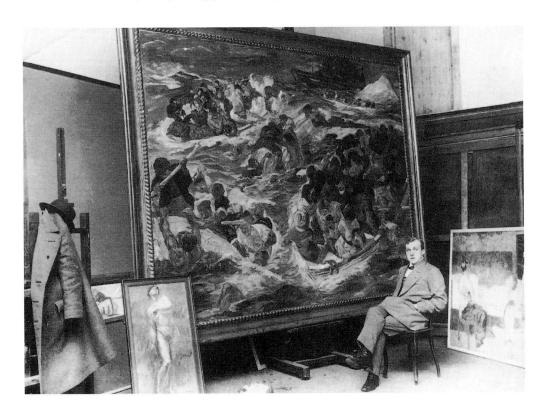

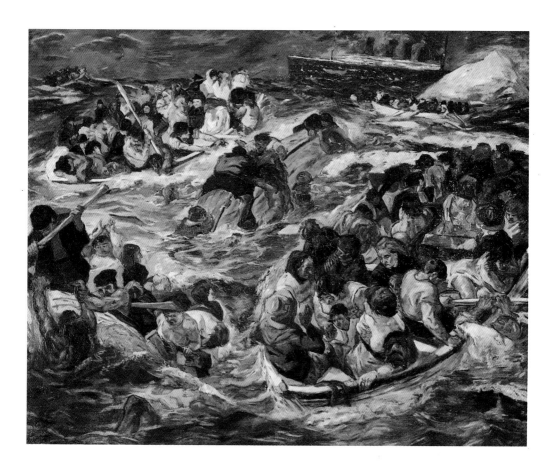

Sinking of the Titanic, 1912

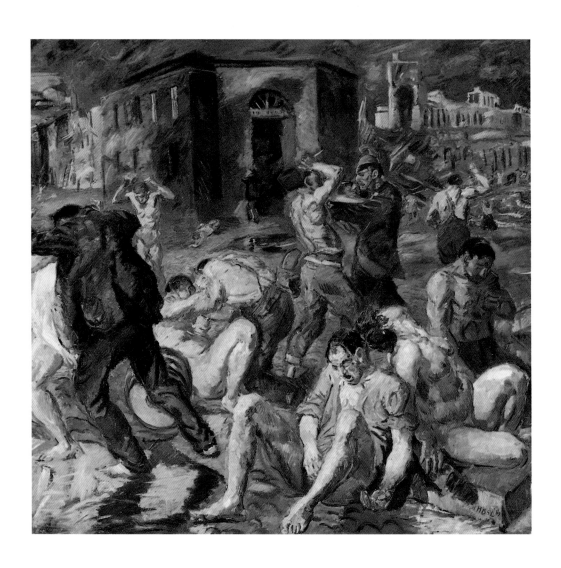

The Destruction of Messina, 1909

"I am quite pleased that there is a war"

The Second World War, it would seem, was most terrible for the non-combatant – the prisoner in the camps, the citizen in the air-raids. The First World War was, above all, an ordeal for the fighting man that even now we can hardly imagine. As an act of collective insanity, it has never been surpassed. Beckmann's son Peter believed that his father rejected the war, but letters and diaries reveal a patriotic enthusiasm in keeping with the national hysteria. This is understandable in the existing conditions, and no one can blame the elder Beckmann for setting off quickly as a volunteer medical orderly. On the contrary, we give him credit for refusing to kill and yet being eager to help. He wrote regularly to his first wife, Minna, and we read his letters expecting any moment that he will wake up to reality and feel the senselessness of this most brutal of slaughters. But Beckmann's letters express no awakening.

Preliminary sketch for *The Destruction of Messina*, 1909

What concerns him incessantly is the artistic value, to him, of such a unique experience. What kind of monster, after a year of it, could write: 'I am quite pleased there is a war', could speak of it as 'incredibly beautiful' and 'uncannily grand' and conclude with a satisfied sigh: 'My art can gorge itself here'? He saw the suffering of his comrades as 'terribly sublime', as 'music'. If he noticed the agonies of the wounded and dying, it seems to have been in terms of colour: 'glorious pink and ashen limbs'. A grenade blows a half-buried corpse from its grave, a Frenchman, whom Beckmann imagines as anticipating the Resurrection (a theme he tried twice to depict). 'I am always thinking to myself', he adds, 'how do you paint the head of the resurrected one against the red stars in the sky [the bombardment flames] … or the blinding white of the aerial bombs …?'[8] This is a course of unmitigated egocentric self-absorption. To Beckmann, the agonies of others were a matter for artistic pleasure, compulsively paintable. The pink and gold young man with Florence at his back walked amidst the carnage, indestructibly present.

But this is to misjudge him. This persistent harping on the 'I', this vision shuttered to all else in war but its colour, was, in fact, a despairing attempt to stay sane. Beckmann shut truth out so as to cope, to do his soldierly duty. Behind the brave brutality of the letters seethed fears of almost insane proportions. He who had always seen the world as 'chaos' and 'grief' (the mad and violent world he tried to control in paintings like *The Destruction of Messina*, p. 24) and who relied on his art 'to order this chaos … to give it form',[9] now found himself overwhelmed by formlessness and horror, helpless. It is very much to his credit that Beckmann tried to survive, even at the cost of his inner truth, and failed. After less than a year and a half, he had broken down in mind and body and was invalided out of the service.

Self-Portrait as Medical Orderly,
1915

26

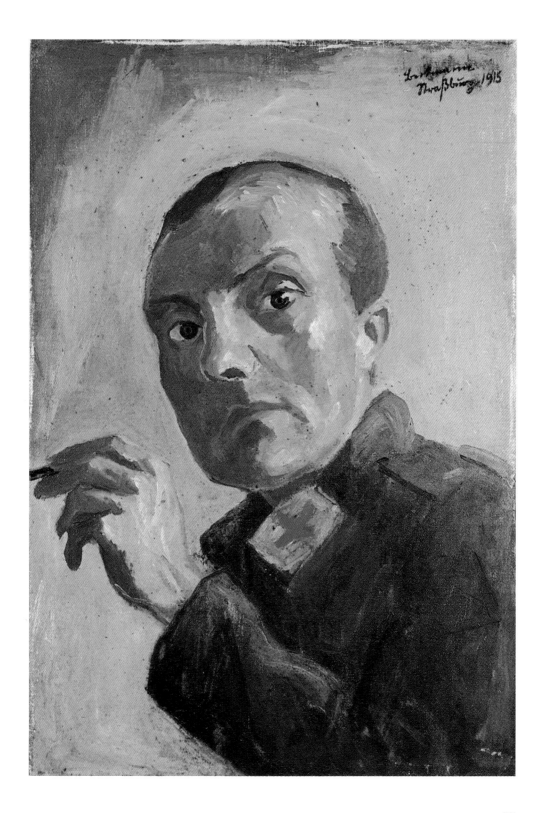

27

Beckmann was a man who took all things to heart. The war destroyed something in him, perhaps his innocence, and for several years we find him desperately seeking to find himself again. The self he had 'lost' was a false self or, at best, an unachieved self, the untried self that looks so serenely out at us in Florence. The next self-portrait, painted in 1915 while he battled to pull something together out of his personal failure, reveals the pitiful depth of his defeat. He is hospitalised still, and still wearing his uniform, in *Self-Portrait as a Medical Orderly*, 1915 (p. 27). Years later, looking at this nasty little picture, he commented sadly on the dreariness of its colour, adding, 'I really slaved away at it'. One of his few confessions before the collapse had been that he felt '[drawing] protects one against death and danger',[10] and we feel that there is an apotropaic quality to this dismal work. Beckmann was saving himself as best he could, trying to find out *who* he was, almost *if* he was, and failing. The body hunches up inside the canvas, constricted and unsure of itself. The chest is too small, the face too large. We are racked by the intense questions in the eyes, hoping to find some confirmation that tranquillity is possible, if not at that precise moment. Light appears to divide the artist from himself; one side, the 'seeing' side, is painfully illuminated, while the other side, the 'painting' side, is in the shadow. He is caught between showing himself in profile and in three-quarter view, a visual contradiction that the cramped, discoloured painting hand cannot reconcile.

Photograph of Beckmann
1915

"Space – space – and space again –
the unending divinity that surrounds us…"

Two years of convalescence later, and Beckmann still had not found himself. He had taken off the uniform and was defiantly civilian once again, but now only as a shabby travesty of the well-dressed young artist. *Self-Portrait with Red Scarf,* 1917 (p. 30) has as its subject a Beckmann who cannot meet our eyes. He is hunched and skinny, framed in the crossbars of an opaque window, nervously straining to keep himself steady. The red scarf hangs round his neck like a noose, while his left hand is tense with some unexpressed signal. He is ferociously concentrated, deeply unhappy. His 'new' art, the art that became natural to him as he rebuilt his health and sanity, was an art that reflected on the Gothic rather than the Renaissance. Madness seems always just beneath the surface, either held at bay by massive self-discipline, as here, or else not succumbed to, but recognised, given form. Perhaps his most famous picture, *The Night,* 1918–19 (pp. 32–33), draws its power to horrify from the artist's immersion in his images. Beckmann is not painting torture, rape, degradation, violence, from the safety of an onlooker, a staff officer at the base. No, he is there in the trenches of contemporary reality, torturing and tortured, causing cruelty and receiving it, painting something terrible and personal. An element in this shocking masterpiece may derive from his actual war work. Beckmann, it must be remembered, had been a medical orderly, an untrained worker in the hospitals and first aid centres. He would have seen many a patient laid out upon a wooden table, in agony for which the orderly had, in his medical ignorance, no remedy. Moving, say, the

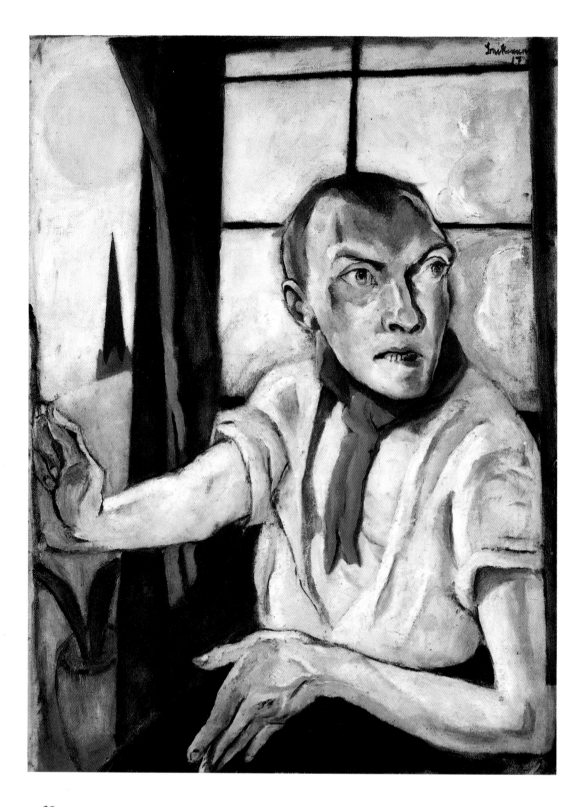

limbs of such a sufferer must often have caused the man pain, however careful the intention. The pipe-smoking figure in the centre has exactly that look of concentration that Beckmann himself must have had. His intention was to relieve, not to give pain, but the result may have been the same. There is a dreadful sexual wildness here, un-palatably recalling Beckmann's ecstatic, semi-erotic response to the thrill of battle and blood. The open mouth of the gramophone is the first of many such symbols in his art: its function here is to present an emptiness, a gaping hollow that can suck into itself the swirling ferocity around it. It is Beckmann signifying that this is chaos, but he is in control. He has ordered it, packing it all into the shallow-est of spaces, squeezing the madness into a comprehen-sible form, so that we can judge and condemn it. It is a nothingness.

For the first time, too, Beckmann was tackling his fear of space. When he gave a lecture in London about his art in 1938, he talked about the 'dark holes of space', how he felt they would crush him, and how in his painting he sought 'to protect myself against the infinity of space'.[11] It had an otherworldly power for him: '… in the beginning there was space, that frightening invention of the Force of the Universe. Time is the invention of mankind, space or volume, the place of the gods'.[12] This was a place that Beckmann would enter in his maturity, as co-creator with the gods, but for now, cringing after the breakdown of all his certainties, all he could do was accept surface limita-tions, like any Gothic artist, and act within the confines of a personal claustrophobia.

The Great War was not good to artists. Several were killed, including August Macke, Franz Marc and Henri Gaudier-Brzeska. Some were wounded, like Georges Braque, or nearly shot for insubordination, like George Grosz. Beckmann was damaged but not destroyed.

Self-Portrait with Red Scarf,
1917

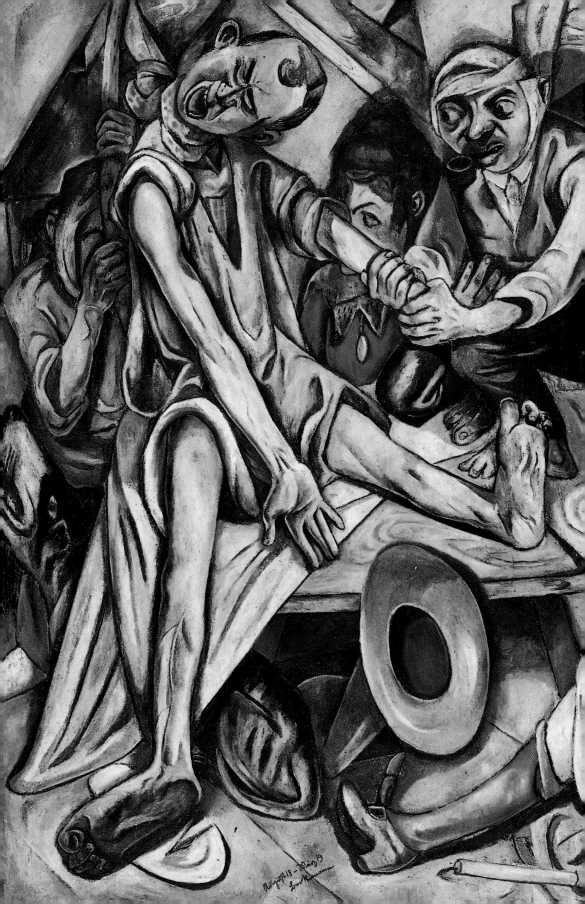

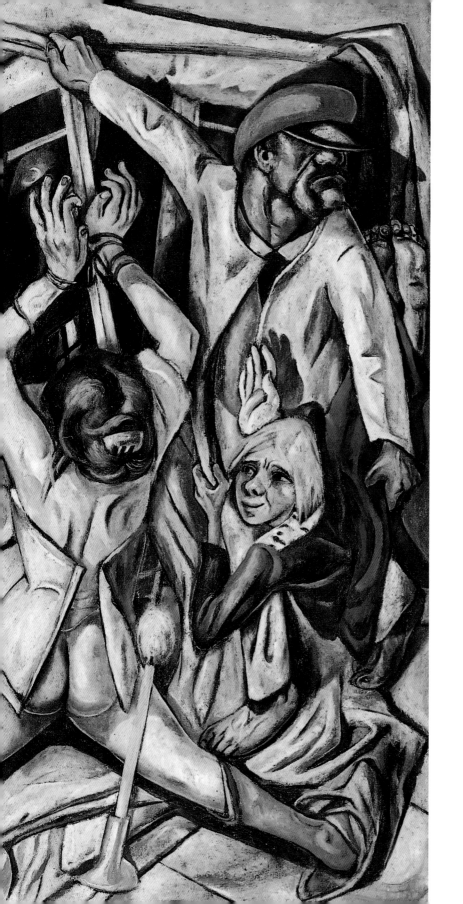

The Night,
1918–19

It could even be argued that he grew in psychic stature through the war, or rather, through his own brave acceptance of what he had witnessed and his passionate determination to learn a bitter lesson. The war made him grow up, and if from now on there was an armour being forged in which to hide, he would only hide so as to advance to safety. Beckmann was not a man to hide 'from', so much as one who hid 'for'. He had experienced his own weakness and the irrationality of life. He could not make sense of it, but he could use his art to live within its horrors and to find a way through.

Nevertheless, Beckmann did not recover from his despair, his loneliness. Every one of his works has the mystery of being human as its undertone. It is not flaunted, but it is a constant presence. Grosz, who shared many of Beckmann's feelings, resorted to the savagery of caricature. Beckmann, a greater artist and a more balanced man, came near it, but did not fall over that dangerous edge. *Self-Portrait with Champagne Glass* is the nearest he got to self-pity or mockery. The man behind the partition, the happy man, the one who could feel at home in the world of post-war Germany – he is a figure that recalls the bitter cartoons of Grosz. Our attention is instead on Beckmann himself, the man who does not fit into this wounded society, but who must nonetheless appear to take his place. He forces a smile, his lips writhing in what he hopes will pass as a welcoming gesture. The falsity is painful, and so is his bodily position, squashed against the bar in a world of no-space. His celebratory drink is for holding, not for enjoying: it belongs by right to the space of the man it toasts, the man behind, the man who belongs. The champagne bottle neck lunges at the artist like a small field gun, hemming him in with its pretence of happiness. Even his clothes are subtly wrong, too short in the arm, and the arm itself seems ill-formed. Beckmann shows himself as a

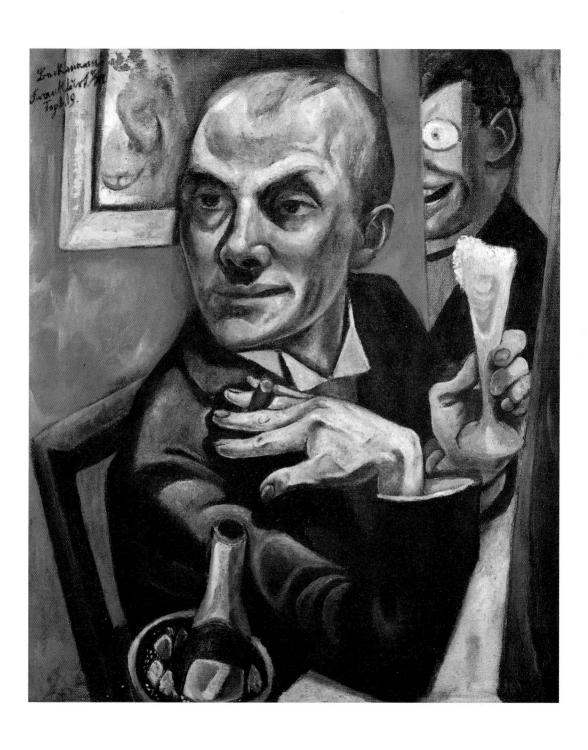

Self-Portrait with Champagne Glass, 1919

35

death's-head, with livid skull, sunken eyes, skeletal fingers. It is 1919, and he is coping, but barely.

Although Beckmann was dearly loved by both his wives (and without his second wife, the elegant Quappi, might not have survived the Second World War), the isolation of his breakdown confirmed him in his belief in himself as outsider. Just before the outbreak of the First World War, he had painted *The Street*, which only exists now in a radically cut-down version, but which he still dominates, alone among the crowd. His first wife brushes past him on the left, and his small son cuts him off with a child's wagon. They ignore him; he looks over them and away. Twelve years later, the theme of isolation had developed. Now he saw everyone existentially, as a solitary, but most of all himself. *Before the Masquerade Ball*, 1922 (pp. 38–39), lays out the family in its living room as if on a shelf. They are waiting, we are told, for a masquerade ball, an image that Beckmann was to use time and again. It contained, he felt, the essence of relationships; one danced, one took part, but masked, free to act only if the Self could remain unrecognised. What strikes us in this painting is the self-absorbed unhappiness with which the festivities are awaited. All are sunk in gloom, killing time, with the sinister and yet therapeutic gape of the musical instrument on the floor. Beckmann actually conceals his eyes; he turns his back, he sways in an unstable chair, and he keeps at his feet his own little open-mouthed horn. Disguise has become a need. This same period saw *Self-Portrait as Clown* (pp. 40–41), with the mask to hand, the horn on Beckmann's lap, the apprehensive cat cowering behind him. These are all pictures of great dignity. Beckmann had concluded that life is farcical, something for which he blamed God. In response, he proclaimed his contempt. He would take part in the carnival, secure in the proud awareness that it *was* a carnival, a nonsense. As late as 1946, he was

The Street, 1914

Overleaf:
Before the
Masquerade Ball,
1922

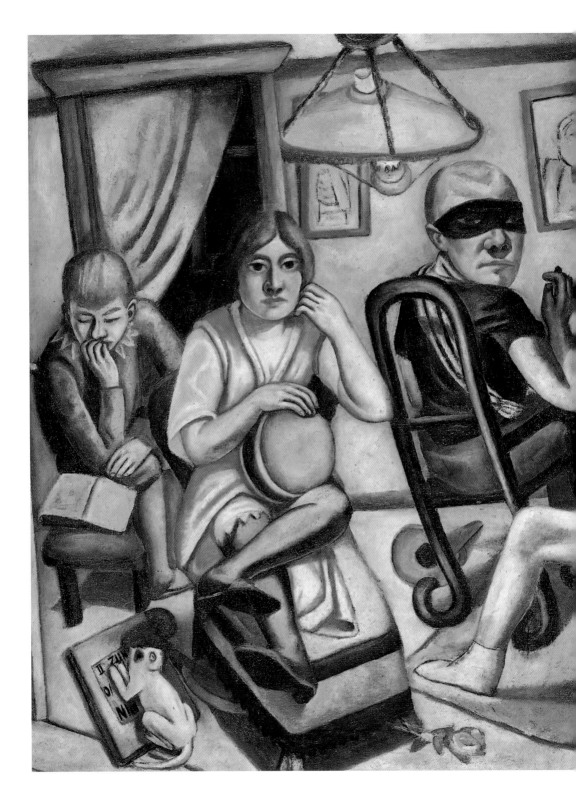

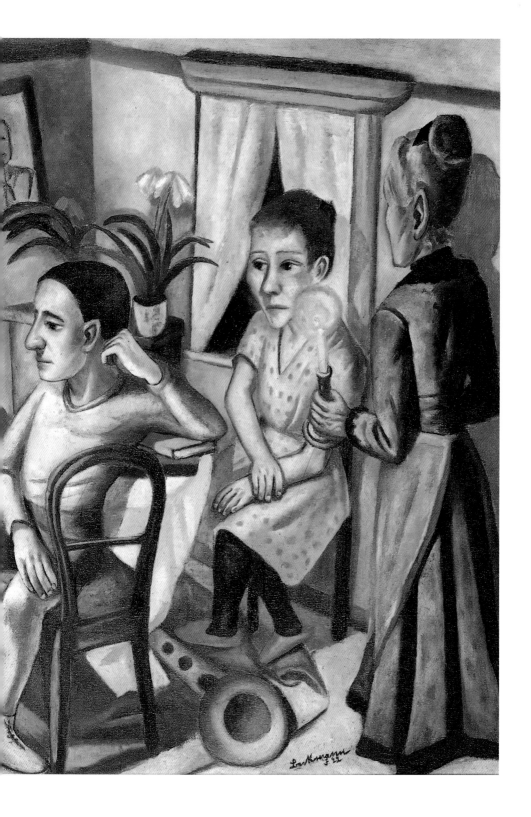

writing of 'the mocking laughter of the gods', how they find us poor humans 'sweetly and endlessly comical'. His resolution was to 'hold on to contempt'.[13] This sense of not understanding the Real, the holy Other, of having to forge our own reality and holiness, caused him constant pain. Beckmann was a deeply spiritual man who could not find his meaning, but who sought it with undaunted passion.

In 1925, the year he married Quappi, Beckmann painted a double-portrait that expresses his alienation and his courage. *Double-Portrait Carnival*, 1925 (p. 43), ostensibly shows the pair entering a ballroom or coming onto a stage. The golden curtains have dropped shut; the figures stand exposed. The actual costumes are light-hearted: Quappi expensively disguised as a rider with a horse, Beckmann more modestly bedecked as a clown or acrobat. He holds his quasi-trademark cigarette, his stand-in miniature for the magician's wand. But the lovers do not communicate. Quappi looks earnestly to the right, as if awaiting, with anxiety, a signal, while her husband presents himself to us with the sad defencelessness of an actor without words to say. His pose has often been compared to that of Watteau's *Gilles* (p. 42), and the resemblance is very striking. Like Gilles, Beckmann accepts stoically the strain of being looked at, of letting others see him, without the protection of either a theatrical robe or the garments of everyday. The crucial difference, of course, is that Watteau is not Gilles; he is a painter standing outside and seeing Gilles. Beckmann chose to paint his own exposure and his ludicrous attire, to put himself on display as well as his beloved. We can only feel that he was convinced of the truthfulness of this approach. Everyday clothing was, to Beckmann, more of a genuine mask than masquerade clothing. Life was a comedy. To acknowledge this and play one's part with dignity was to know one's self with greater certainty.

Self-Portrait as Clown, 1921

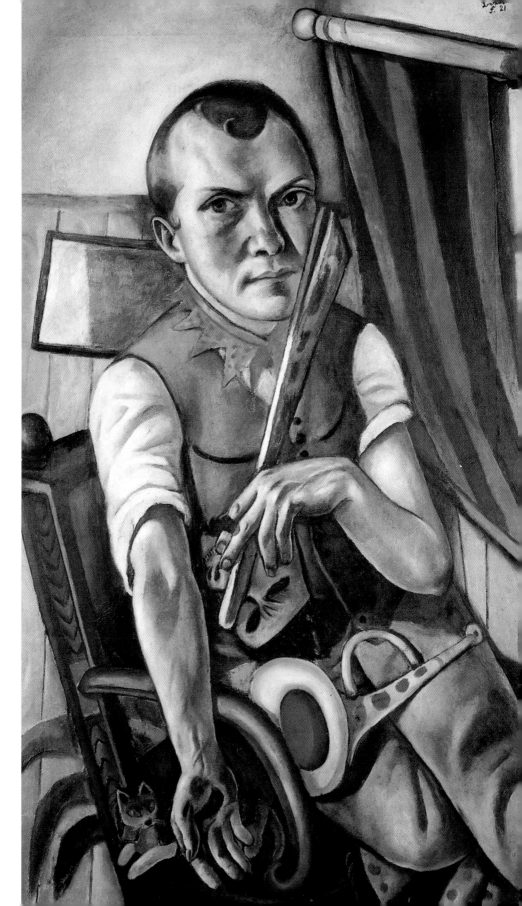

Beckmann's greatest self-portrait takes this discovery and inverts it. *Self-Portrait in Tuxedo*, 1927 (p. 44), works on the premise that the tuxedo, the aristocratic dress suit in which Beckmann always felt completely at home, was in itself a masquerade, a pretence of dignity and decorum to which no one was truly entitled. If the gods laugh at the clown, they explode with mirth over a man in his stately black-and-white. Beckmann fully came to terms with this. He refused to be cowed. In this portrait, he towers in his strength, merely human, but that is all that is possible. The canvas cannot contain him, suggesting that he is of giant stature. In one hand, he holds his small wand, his lighted cigarette; his other hand rests casually on his hip. He has assumed full responsibility for himself, abjuring defences, refusing the soft weakness of emotions. He could write vehemently about our need to be free of our emotional vulnerabilities: 'The more strongly, deeply and burningly I am moved by our existence, the more resolutely my mouth is closed'. And again: 'I do not cry, for I despise tears and consider them to be a sign of slavery'.[14] This mouth is certainly clamped shut, a grim line of implacable will. The eyes are set deeply in their sockets, one almost completely occluded, tearlessly assessing the possibilities of the future. Some have thought this an arrogant paint-ing, too self-assertive. Others have seen it as Beckmann's artistic coming of age, claiming the world for his oyster. Certainly, it is the work of one who feels that he knows what he is doing. It makes not just a physical statement – this is how I looked, aged thirty-three, recovered from the horrors of the war, in control again – but a summation for Beckmann of the meaning of his 'self'. His calling, his very being, was to breast the irrational waters of a divine deep and refuse to panic or succumb. Human beings had a duty to tame the chaos, and if that meant adaptation, fitting into the pattern of the world (as he does here, neatly framed by

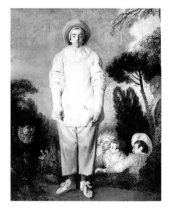

Antoine Watteau, *Gilles*, 1717–19

Facing page:
Double-Portrait Carnival, 1925

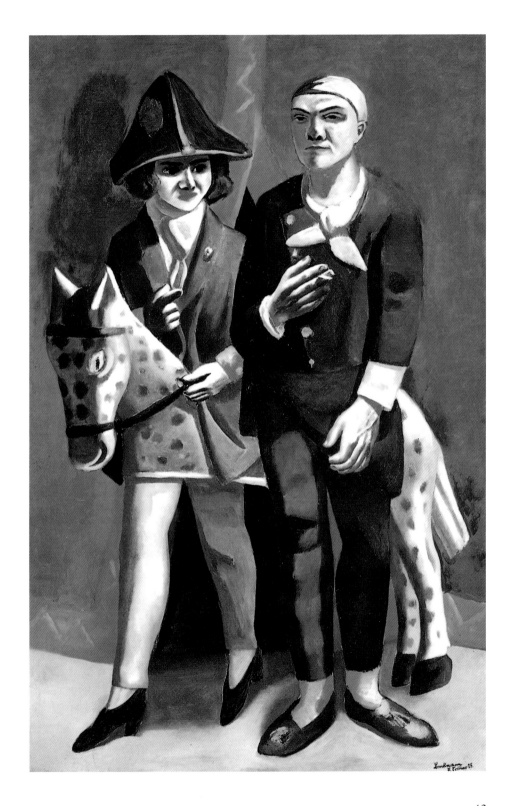

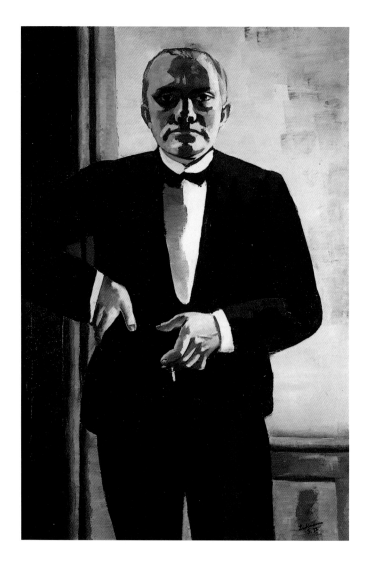

Self-Portrait in Tuxedo, 1927

the brown wainscoting, but with an ominous and unex-
plored segment of darkness at his side), then they had to
stand erect and do their best. This is, in its mature fashion,
a state-of-the-soul work, as was the 1907 *Self-Portrait in
Florence.*

44

*"I have now prepared myself
to be treated again as a nobody"*

Once again, these certainties were to be attacked. Beckmann would never waver from what he had formulated as the essential tragi-comedy of life, but he was to learn all over again that we can never boast a readiness to cope. Six years after this triumphal statement, the Nazis came to power, and Beckmann found himself under attack. He was dismissed from his teaching post; his art ceased to receive official approval. Professionally, he lost his footing. A thinking man like Beckmann must have viewed the suicidal nightmares of the Nazis with incomprehension and disbelief. Could he have imagined in his security that within four years his art would be excoriated as 'degenerate', and the towering *Self-Portrait in Tuxedo*, proudly exhibited by the Nationalgalerie in Berlin in its Beckmann room, would be hastily removed amidst public mockery? Perhaps he did have a suspicion. In 1932–33, as the Nazis readied themselves for power, Beckmann painted *Departure* (pp. 46–47), the first of his mighty triptychs, a format that was peculiarly congenial to his complex and ambivalent nature. When asked by his dealer Curt Valentin for an explanation of this haunting work, Beckmann, never one to use words when paint would do, said briefly that it meant, as entitled, 'Departure, yes, departure from the deceptive surface appearances of life, to those things which are essential in themselves, which stands behind the appearances.'[15] We respond instinctively to this metaphysical reading, and yet the ascent of the Nazis did indeed presage a departure for Beckmann, and at some level he may well have sensed it. The triptych remains an

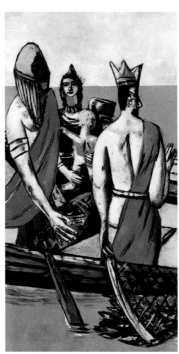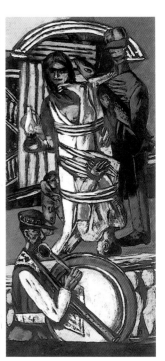

Departure, 1932–35

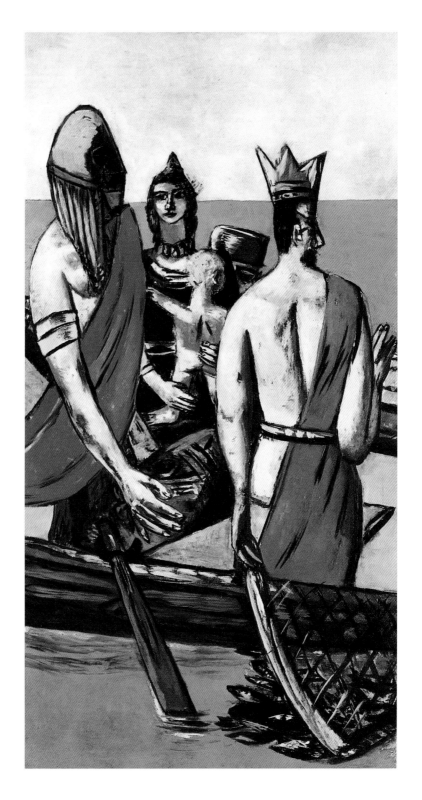

overwhelming work. At the left, we have echoes of that seminal painting, *The Night*, in which Beckmann anatomized the human soul, our evil complicity in cruelty and our moral detestation of it, both equally true. Here again, torture is rampant, with men and women helpless in their chains, bound arms lifted in despairing prayer. The executioner hoists his club in the presence of a majestic still life. The victims are faceless; only evil has an identity. The right panel depicts not physical cruelty but psychic mayhem. Man and woman oppose each other and yet are intimately fettered. The bellhop, one of those who should serve and deliver messages, is blinded, and in the hideous spacelessness of their prison, there is the mindless racket of the big drum. Both side panels expose humanity as bound, suffering, imprisoned. But in the centre, all is completely different. Here, there is a limitless horizon of blue sea and a boat for sailing out to it. Human strength, its potential for violence as personified by the Viking, has now been harnessed for good. The queen (a Quappi look-alike) waits serenely with her naked child; the king, with Beckmann's large head and jutting nose, draws in a brimming net of fish with one hand and lifts the other in farewell blessing. All the bonds here are voluntary: the warrior and the queen decorate their bodies, and the king girdles his thighs. Silence, peace, freedom: this is what *Departure* hymns, and it could be that already Beckmann had guessed that he would not enjoy these fundamental blessings without journeying into exile.

It took time for him to realise that the situation was hopeless, that at some level he had already been rejected by the Establishment. When he sought the Self without the subjectivity of direct self-portraiture, his work seemed as confident as before. Compare *Brother and Sister*, 1933, with the almost contemporary *Self-Portrait in a Large Mirror with Candle*, 1934 (p. 51). *Brother and Sister* acknow-

Brother and Sister, 1933

48

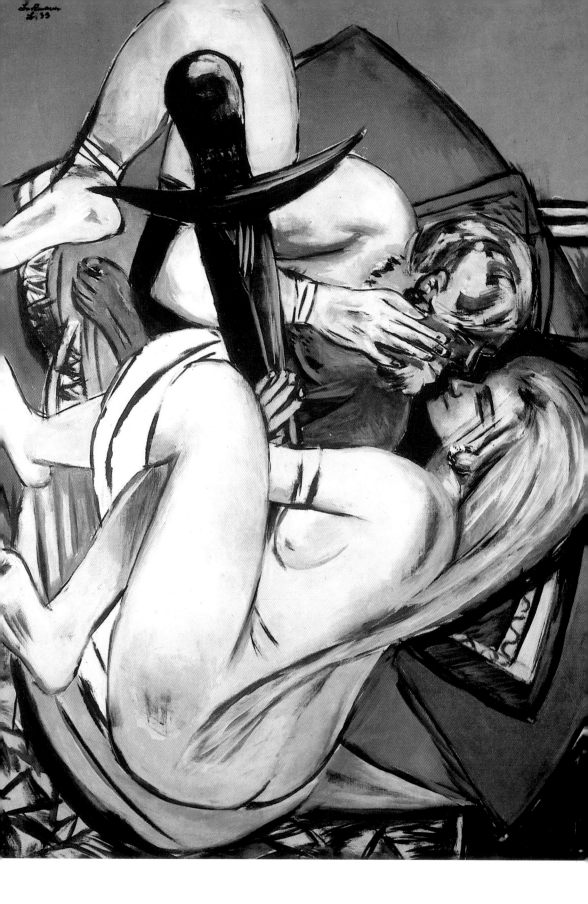

ledged the change of government by altering its title. It was originally called *Siegmund and Sieglinde*, from the old Norse legend of the Nibelungen. But Hitler had hijacked Wagner to his own political ends, and Beckmann felt he must make his artistic point less specifically. This is a very powerful painting, with man and woman opposed, fatally held asunder by their moral code, a dark sword thrust between them and a wounded beast. Their lips approach but will never meet, the pale parabolas of their bodies sweep in harmony but separately. It is a wonderful patterning, an assertion of unity that denies itself bodily fulfilment. We cannot but notice that the man looks strangely like Beckmann himself, a tormented Beckmann denied his rights. This is a mere hint: the 1934 self-portrait spells it out with melancholy clarity. Here is a great oblong, where the aspiring candle, always an image of life for Beckmann, still flames. There is a wine bottle diminished by a water bottle, a subtle suggestion of quality diluted. There is a pair of spectacles laid down, as if there are sights not willingly seen. There is the ivory and black page of an open book, seemingly a sketch pad with graphite drawings of ships under sail or in a harbour. There is an enormous, towering agave plant, stretching across into the rust-red reflections of the mirror, in which we see the black profile that is Beckmann's self-portrait. He alone is reflected, as if he alone has full dimensionality, full visibility, yet he alone does not 'appear'. It is as if he can risk only his profile, his shadow, even though the sweeping frond crosses his brow like a victor's laurel wreath. Beckmann is not afraid; his appearance is as aggressive as before, but there is a sadly muted quality here. We sense uncertainty. Does he still know who he is, as he thought he did in the past? Where is the Self, if it can only be glimpsed in shadow and reflection?

Self-Portrait in a Large Mirror with Candle, 1934

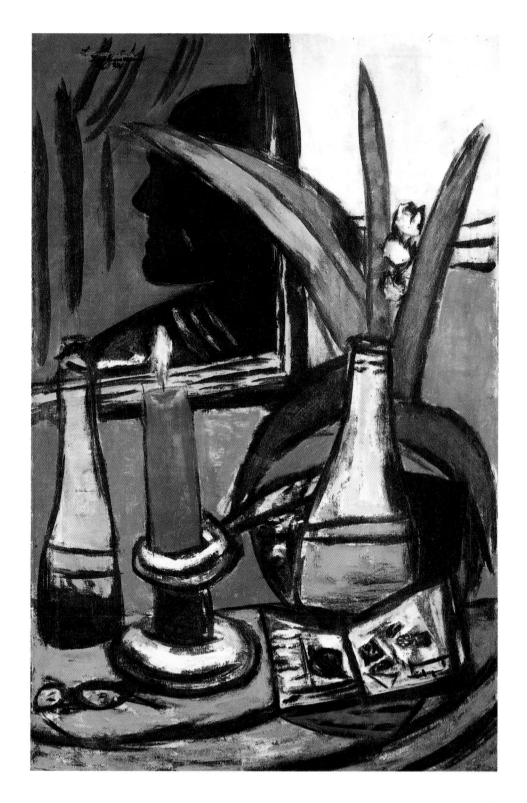

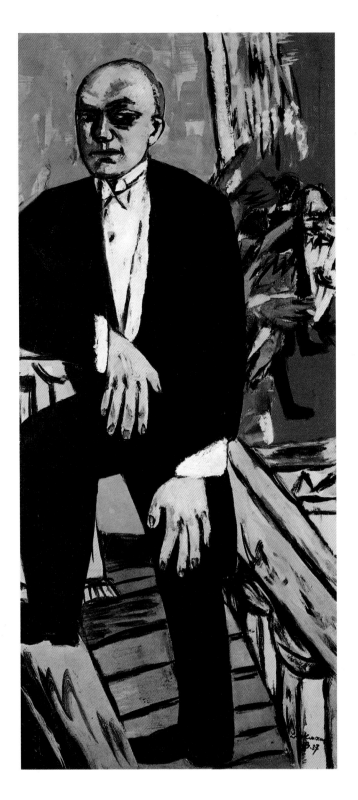

Self-Portrait in Tails, 1937

"I opened my eyes and found
I was in Holland, surrounded by the
boundless confusion of this world"

In 1937, Beckmann admitted defeat and went into exile.
That year of heart-searching impelled him to three self-
portraits, of which the first is the most painful: *Self-Portrait
in Tails*, 1937. The carapace – the tuxedo of power – re-
mains. But the man inside has dwindled. Now his body
edges out of the picture frame; he no longer feels con-
fident of confronting his viewers head to head. The mouth
is twisted; the eyes darken and sink, reminiscent of his
wartime self-portraits. He stands, or at best balances, in a
threatening no-space, where stairs metamorphose into a
chute, and balusters press menacingly inwards. Behind, in
somebody else's world, there is frenetic activity. In his en-
dangered state, where an artist's hands can hang limp and
ugly and there is nowhere to rest an elbow, existence is
mere endurance.

 We can trace the change in Beckmann's awareness of
his true self in the two versions of *The King*, done in 1933
and 1937 (pp. 53–55). This is the artist in familiar clownish
costume, but wearing the royal crown. In the earlier ver-
sion, which we now only know through a photograph, he
has still immense self-possession. He sits on a severe
throne, flanked by women – the clinging young beauty,
the ominous old sage. He is supported by a pillar to the
right and an open expanse to the left. His eyes survey us
gravely but calmly. If there is anxiety, it is behind him,
where he cannot see it; the hooded woman regards him
with foreboding, and we deduce (this is 1933, remember)
that trouble may be on the way. In 1937, the trouble
has come, darkening the scene, frightening the woman,

causing the king to draw himself up to encounter his fate. Beckmann grew increasingly addicted to the black line, a heavy outline around his images, as if to make their impact inescapable. This can become almost a savage underlining, as here, where parts of the picture thicken with ominous significance. The old woman has darkened into an over-cast profile, with shadowed hand warding off approaching evil. The girl has moved from before the throne to a strangely intimate position between the king's legs. She clasps him, terrified, gently immobilising his hands. And who is the king? Beckmann disguised? His noble head is practically unreadable: this is his own private affair. What is shown is his attitude, one of sovereign control. No clown's dress can make a fool of a true king, and if his escape seems barred in all directions by bizarre obstacles,

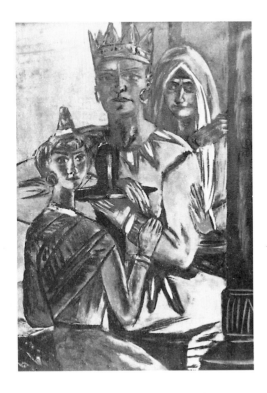

The King (First version), 1933

Facing page:
The King, 1937

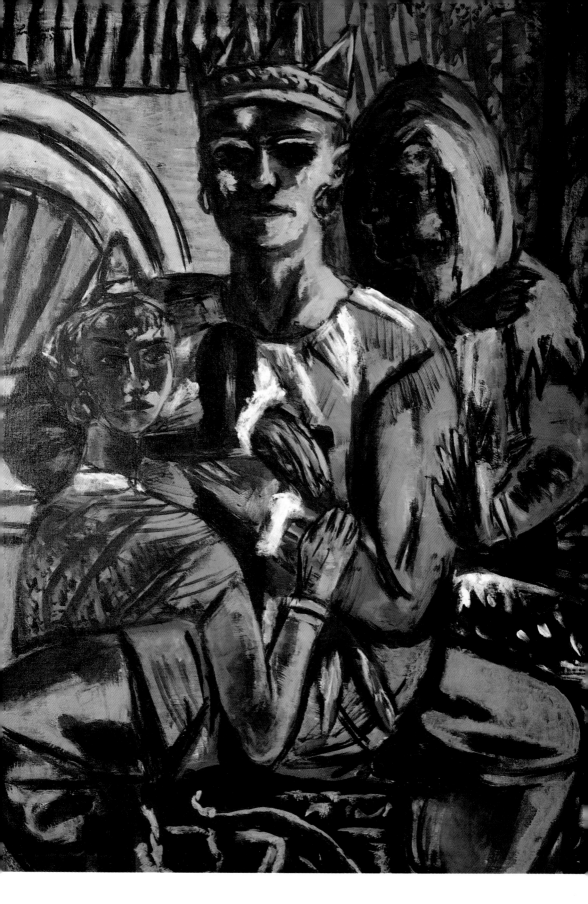

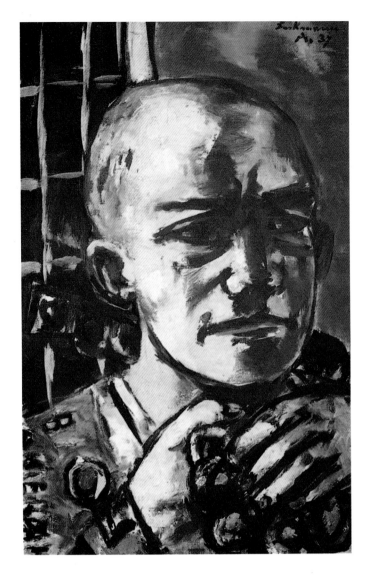

The Liberated One, 1937

he is undeterred. With its deeply glowing colours and rich, positive lines and blurs of black, this is one of Beckmann's most memorable achievements.

It is also, in a gesture of painful irony, his farewell. His next self-portrait (done later in 1937) was painted in Amsterdam, and here, too, irony is inescapable. He called the

work *The Liberated One*, 1937, yet it is the least free of any of his self-images. It is Beckmann at his most despairing, experiencing with passionate anger the illusion of a freedom that is only geographical. His eyes stare away from us, into a pitiless future. His thin trap of a mouth is shut on all emotion. Only that fixed stare, tensely maintained, tells us that this is not the livid head of a dead man. His chains have been physically severed, yet he still wears the fetters, and they occupy his painting hands. His mind is obsessed with imprisonment, its different guises, its personal inevitability. There are thin steel bars behind to his left and a wall of smeared blood-red to his right. Even his jacket looks vaguely like prison wear. But none of these constraints preoccupy him, only his own lonely predicament. If he is to be free in spirit, how can he be himself? Where does his inner truth lie? This is the artist who would later (in 1948) write to his son, 'It is our greatest hope that we *know nothing* I am content that I *do not know,* for that gives me the certainty of an unknown solution, which is both path and goal'.[16] The bitterness of losing himself, of discovering himself to be artistically bound, a man still in mental chains, may have been the impetus that led him to this mystic freedom. Even here, the Liberated One has not forfeited dignity. He crunches down on his pain and looks not away but towards. From the misery of works like this, Beckmann would draw the wisdom that he expressed to his son and made visible only a year later, when he began his next self-portrait.

Self-Portrait with Horn, 1938 (p. 58), like the previous painting (p. 59), is a rethinking of an earlier work that we now know only from photographs, *Self-Portrait with Saxophone* from 1930 (p. 61), which was painted in Paris when Beckmann was riding the crest of his wave. He felt he could encompass contradictions, wear an acrobat's tights and an aesthete's quilted dressing gown, and still be effort-

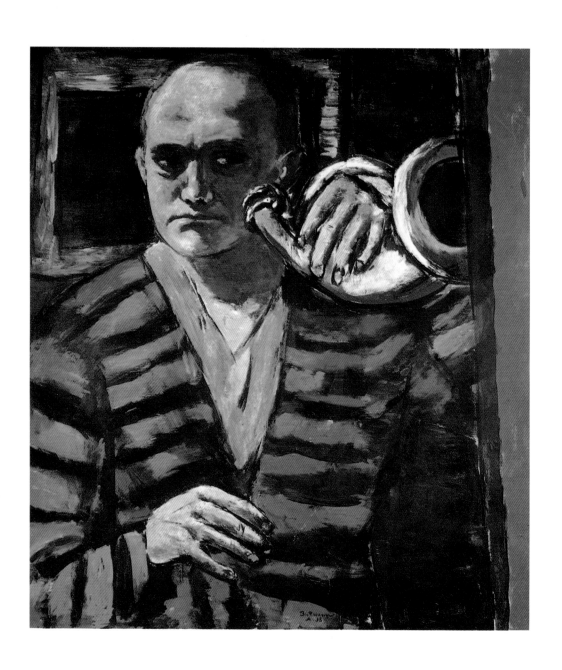

Self-Portrait with Horn, 1938

Self-Portrait with Horn, 1930

lessly dominant. The saxophone, uniquely, may not represent music and its power to engorge all sadness and transform it, but modern life. He holds the instrument low, subduing it as it curls animal-like around his body. The saxophone resembles nothing more than a piteous snake, a mini-dragon, and Beckmann, its St George, wrestling the animal power to his own purposes. It is a splendid image of a man at rest in his own superiority. Some years later, and he is assaying *Self-Portrait with Horn.* Now the instrument is acknowledged as partner. The horn, after all, has old Germanic connotations. The saxophone may be modern, a jazz band instrument, but the horn had sounded since ancient times in Teutonic forests. The lost picture is a rare depiction of Beckmann smiling, even if the smile is

rather wry. He points meaningfully to the horn, almost as if offering it to us as validation of his integrity. A globe glimmers obscurely in the background. The 1938 painting, the final and definitive version, moves into deeper waters. This is Beckmann the prophet, the seer (as, of course, every great artist must be by definition), the mystic who has learned that the highest wisdom is not to know. Behind his dome-like head, grim yet flushed with life, is a gleaning square, a 'square halo'.

Despite his rudimentary secondary education, Beckmann was a very cultured man, a reader of classical texts ranging from the biblical to the philosophical (especially Nietzsche) to the psychological (especially Freud and Jung). He had a deep interest in Eastern religions and their imagery. So perhaps the square halo here has its medieval meaning, signifying not a saint (who would have a rounded halo) but a person still alive yet already venerated: a spiritual hero. It is clear that this portrait is concerned with some kind of esoteric communication. Beckmann does not blow the horn; he is listening. It has already been sounded, and now the artist waits for the echo, the response. He presents an overpowering image of concentrated attention. The French mystic Simone Weil (a Jew who longed for baptism but did not feel herself worthy) described prayer as a state of 'attente au Dieu', a waiting on God. There is a spiritual gravitas about this painting that recalls that higher form of attention. Beckmann, we feel, is not waiting for a human response to his call – or not only, or primarily, a human response – but something much more fundamental to the Self. He waits in a dedicated silence, ears alert for his 'answer'. This is a work painted with ravishing beauty, the red and black stripes on Beckmann's gown irresistibly subtle in their tone. Now, having found his truth again, however different it might have become as a result of his years of success, his hands are no

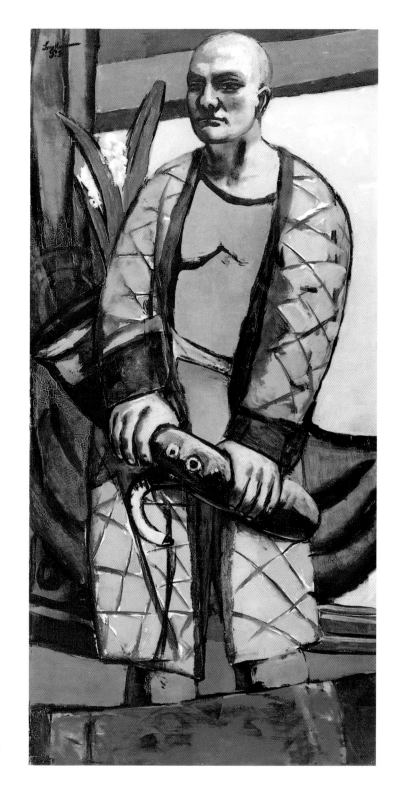

Self-Portrait with Saxophone,
1930

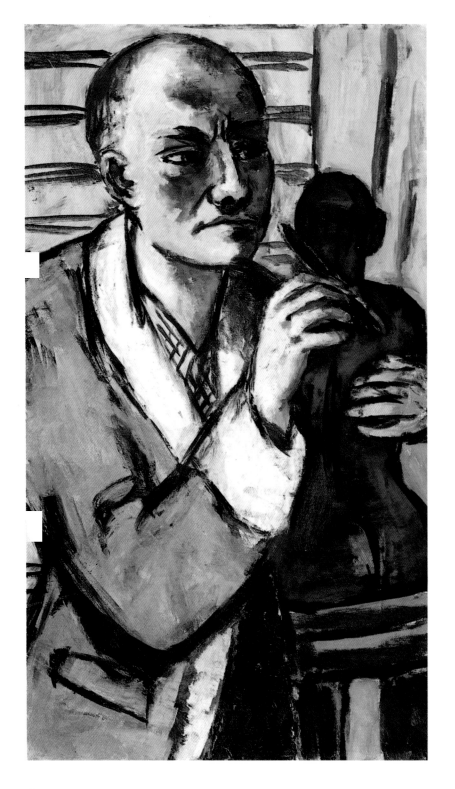

longer flaccid, but tense with expectancy. Even the mouth of the horn, so often the absorber of unhappiness, is now bisected, as it was not in the pre-1937 version, as if its function has been transformed. The artist uses it almost as a stethoscope, sounding out the depths of truth. This is Beckmann at last in touch with his secret self, not circumscribing it with specific imagery, but conveying his strength simply. We are reminded that *The King* contained elements that hinted at Eastern mysticism, as though Beckmann anticipated the possibility that he might be called to the role of prophet. In the most understated of ways, *Self-Portrait with Horn* seems to have prophetic implications.

There is a sense in which exile was appropriate for Beckmann. He had always sensed himself to be alone, unable to lose himself in society. He spoke about 'the island of one's soul', and yet experience seemed to convince him that other people lived on a continent, and only he and a few like-minded artists knew the isolation of that solitary island. He had resigned himself to not being understood, explaining: 'I can only speak to people who consciously or unconsciously, already carry within them a similar metaphysical code'.[17] Nevertheless, Beckmann struggled to communicate, to share. For some years, he even turned to sculpture, and there is a masterly self-portrait in bronze from 1936. The painted *Self-Portrait in Grey Robe*, 1941 broods upon this creative activity, so much more physical and Promethean than the art of painting. A thin and anguished Beckmann, sombrely clad, clutches a vaguely human sculpture. It is not quite that he is modelling it, because his gaze slips away, past the figure, to become lost in private speculation. It is more that he embraces it, clings to it, sadly but ardently. He writes in his diary of these exile years: 'Playing the powerless role of the creator is our tragic occupation',[18] and one picks up in this painting an air of disbelief in the artist's own activity. What one feels

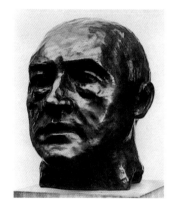

Facing page:
Self-Portrait in Grey Robe, 1941

Self-Portrait, bronze, 1936

he is really doing is something deeper and more personal: he appears to be fashioning himself. This 'self' is still alien to him, not a thing of flesh and blood, yet he is in an intimate relationship with it. As in *Self-Portrait with Horn*, he is waiting, watching what will come into being, anxious to do what it is in him to do, however inadequate that might be. This is one of the most tender and undefended of all the mature self-portraits; it exposes a little of what it means to be an artist. Beckmann is colourless in himself and in his context, his private world. All the colour and interest are in the small figure he has shaped, richly bronzed, almost a small god to whom the artist reaches out for comfort and support.

Yet Beckmann, with his charismatic presence (everyone, we are told, recognised at once that they were in the company of greatness) was never without at least some comfort and support. His second wife devoted herself to him, and both his first wife, Minna, and their child, Peter, admired him unreservedly throughout his life. The 1941 *Double-Portrait, Max Beckmann and Quappi* spells out the terms of his second marriage with a frankness found nowhere else. (Despite his reiterated self-portraits, Beckmann was a deeply private man.) This is a self-portrait with his wife; she tucks herself neatly into his side. It is he who addresses us, she who looks modestly away. Yet, in this mundane world, where *we* might not fit in if we do not know and keep the rules, it is Quappi who seems more at ease. Beckmann looks choked by his muffler, encumbered with his walking stick, ill at ease with his elegant hat. There is something of a stranded whale about him, an exile in Holland and for once without much money. His wife's hand rests lightly on his shoulder as if to steer him, her fashionable little shoes trip forward with some certainty, while her husband hesitates, seems to feel for a footing on this alien carpet. None of this is admitted;

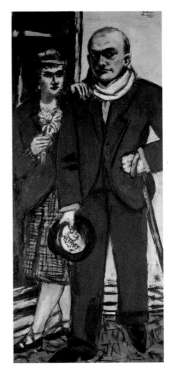

Double-Portrait, Max Beckmann and Quappi, 1941

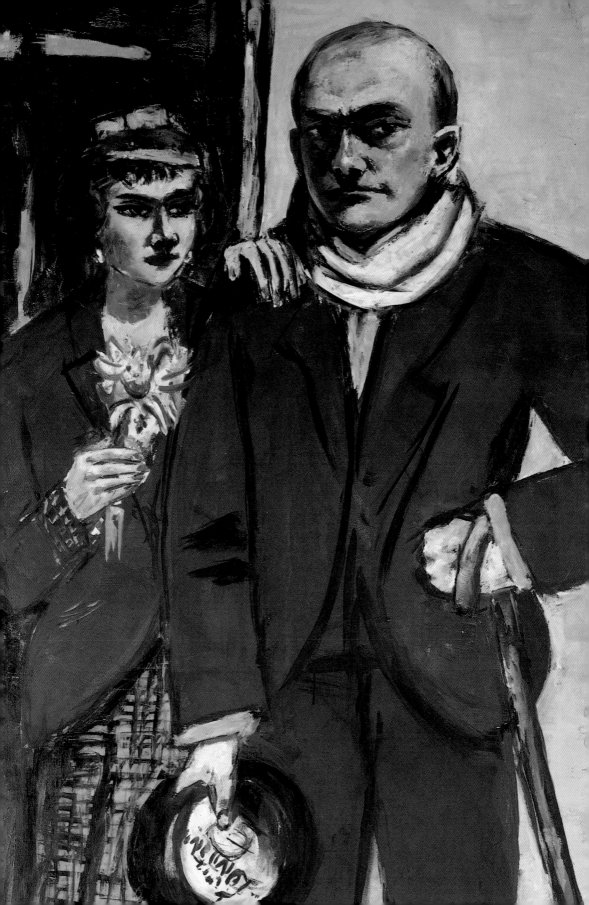

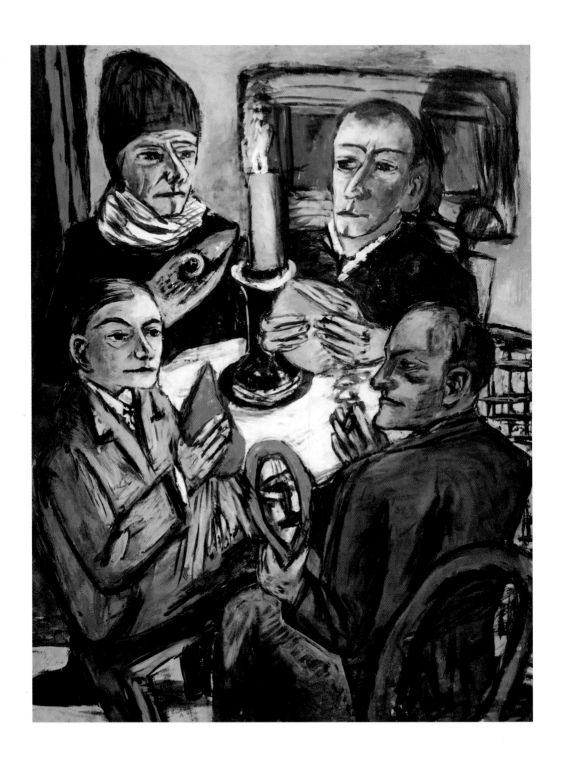

Les Artistes with Vegetables, 1943

naturally, he glooms out at us, disgruntled but in command. We feel, all the same, that the worldly motor power in this partnership is the woman's. The great advance on the 1925 double portrait is that there is no longer any need for carnival disguise. The figures are still just as separate, as distant from each other as they were then, but an acknowledgement of their mutual dependence has grown and helped them. If Beckmann affronts the fates and dares them to do their worst, Quappi is at his side to share his future, united if apart.

There is both more and less support in Beckmann's only group portrait, *Les Artistes with Vegetables*, 1943. Beckmann himself is unmistakable at the bottom right. The other three figures are all Germans who had fled the persecutions of the Nazis. One, the rather skeletal figure in the upper right, is a poet, Wolfgang Frommel, the only 'artist' to expose his neck. ('Sticking his neck out' in the company of visual artists may be a piece of friendly fun.) Beside him is the painter Otto Herbert Fiedler, a relatively obscure figure who is intent on obscuring himself with low-slung woolly hat and high scarving. At the bottom left next to Beckmann is the Constructivist-abstract painter Friedrich Vordemberge-Gildewart. Although Vordemberge-Gildewart looks smilingly towards Beckmann, his art was of a kind with which Beckmann would have had little sympathy. One feels that abstraction baffled him. 'I hardly need to abstract things', he told his London audience when he lectured there before the war, 'for each object is unreal enough already, so unreal that I can only make it real by painting it'. Put another way, he could declare that 'It is not subject which matters, but the translation of the subject into the abstraction of the surface by means of painting'.[19] True art, he believed, is abstract in handling yet realist in subject; it was what the artist made of it that counted. There may again be a private joke here,

in that his Constructivist friend holds a three-dimensional triangle. This carrot-coloured object is in fact turnip-shaped, another sly comment. Only Beckmann holds no food, but rather a mirror in which he sees not himself but some sort of primitive image, some creature of another time and space. All four men sit round the candle of life, and fish and bread are both mystic symbols, yet one cannot but feel that Beckmann has the best of it. The artists all look away from one another, out into the unknown, again except for Beckmann. He narrows his eyes as he gazes into his intimate enigma, the secret fact that only he can see. However shut in they are together in their small room, doorless and windowless, each of these artists is enclosed in an impenetrable solitude.

There is a terrible drawing of c. 1945 which reveals something of the frustrated creativity, the lack of stimulus, the isolation in a foreign land, that Beckmann learned to live with in his ten years without a base. *Double-Portrait, Max Beckmann and Quappi* shuts them both up in a low-ceilinged box, blocked to the left and the front, enclosed from behind. At the right, the paper ends. Max overlaps the sketched constraints that shut him in, but he can only do so by standing still, enduring, evading them in his mind. Quappi too looks grim, but she has a solace, their small dog, which she holds to her breast like a baby. She is quietly there, but she does not stand by the artist's side as she does in the other double portraits. Very deliberately, she looks past and beyond him while he affects a sad and lofty indifference. Nothing is solid about them except their bodies (and that of Butchy, the pup). They seem to have retreated into their minds, to memories and decisions. Beckmann's hands are still vibrant with power, though they merely hold his signature cigarette and point with mysterious emphasis to the floor. He is girt for work, and Quappi for society, but opportunities present themselves

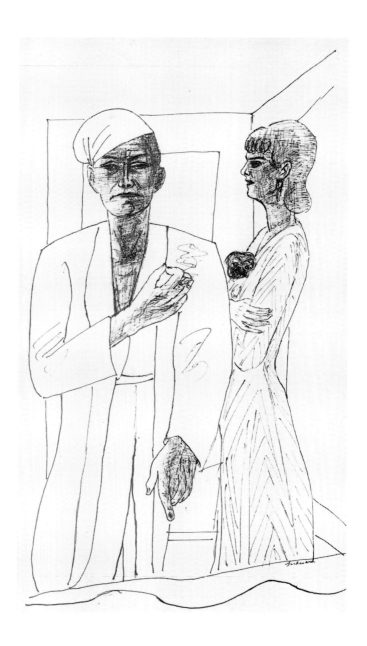

Double-Portrait, Max Beckmann and Quappi, c. 1945

to neither figure. If Quappi's lips are lightly parted, as if to speak, Beckmann's mouth is a long, straight gash in his face, painful as a wound. One is left wondering what will become of them if their frustration is not eased and peace does not come.

This same tightness of mouth, like a steel trap slammed shut, is obvious in *Self-Portrait in Black*, 1944. Beckmann had solved his anxieties by re-inventing himself, withdrawing from the fray, hors de combat. Here, he pictured himself, not unfairly, as the objective onlooker, remote but concerned, leaning Jove-like over his easy chair to assess the damage. He had emigrated in his mind, something he believed an artist ought to do at intervals. When he came to read Richard Wagner's autobiography, he decided that their fates had much in common: 'Even though I have not exactly busied myself with barricades, it seems that an emigration of ten to fifteen years simply belongs as an organic part of every essential personality'.[20] Beckmann was to have thirteen years of exile, of emigration, ten in Holland, forced upon him, and three in the United States, reluctantly chosen, but chosen nevertheless. This picture hints at something more profound. He is bodily very much with us, looming forward into the viewer's space, dominating the picture frame, filling and overflowing it. The dense black of his suit, with the luminous gleams of collar and cuff, acts as a sort of platform for the great oval of that massive head. His face is almost wholly shadowed, unemotional, unreadable. A light plays on him from the left, but he ignores it, staring instead into the darkness, towards the viewer. We watch, and he watches back, inscrutably. He has cloaked himself in individuality and refused to live on a level we can understand, and yet this does not strike us as retrograde.

It is as if Beckmann had come so close to his inner truth that he needed now to protect it, to try it out obliquely against the familiar patterns of ordinary existence. He worked with furious intensity. Typical diary notes read: 'Wed. Oct 25, 1944, furiously finished *Pink Woman with Playing Cat.* – sketched six or seven Caliente paintings', and in September: 'Sat. made 5 sketches, two *Departures*,

Self-Portrait in Black, 1944

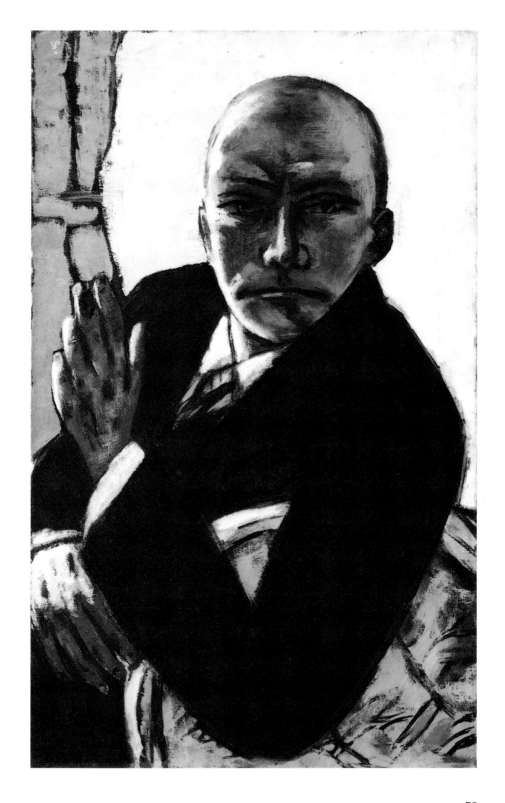

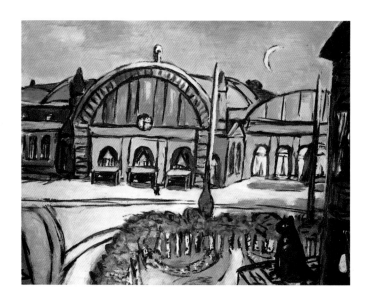

Frankfurt Train Station, 1942

Yellow Lilies, Negerbar and *Two Women. Frankfurt Train
Station* is finished'. A day's rest and 'already all kinds of
nonsense boils up within me demanding a form – perhaps
the story of David – or something, we'll see'. Creativity
maintained at such a pace was only possible if he had
made peace with his own profoundest needs, the quest
for who he was within. For much of his life, he was torn
between consciousness of the Transcendent and doubt
about the very meaning of humanity. He felt that 'there
was still some sort of force which wants to be eternal but
which is still deeply convinced of the pointlessness of it all'.
He describes himself in his diary as 'always waiting to see
whether or not one can unveil the mystery ... weaving
ideas together out of nothingness, which keeps everything
in a steadily intensified state of tension'.[21] It is this silent
waiting, tense but at peace, that makes this self-portrait so
striking. Beckmann the man seems almost to have receded
behind the iconic mask, living his real life on a plane we
cannot reach. If it is wishful thinking on his part, then at
least the wish came from very deep within him.

*"You cannot conceive how uplifting it was
for my soul coming to this peaceful country"*

In 1947, when the war and its aftermath had been more or
less settled, Beckmann and his wife sailed to the United
States, where several universities were eager to have him
teach. His letters and diary comments reveal a deep fatigue.
He was only in his early sixties, yet he had lived at such a
pitch of emotional intensity that his capacity for response
sounds strangely muted. He wrote of himself in an affec-
tionate third person: 'Beckmann finally moved to a large
and distant land – and gradually we saw his image becom-
ing less and less clear. At last it disappeared altogether in
the indeterminable vastness'.[22] Two things strike us here.
The first is the sense of finality: 'finally', 'his image disap-
peared'. This may be no more than exhaustion after a long
period of stress, but this is the Beckmann who affirmed:
'All I know is this, that I will consecrate all my energies to
following the idea I was born with … until I can go no
further'.[23] He emphasised that he had never wavered in his
understanding of his creative vocation. Could these ex-
pressions mean, then, that Beckmann felt that 'he could go
no further', that he had found what he sought? Towards
the end of his life, he redefined this search: 'I have tried my
whole life to become a kind of "self". And I will not desist
from this …'.[24] The self-portraits from 1937 onwards
do suggest a spiritual resolution, a mystical certainty at
having 'become a kind of self'.

Parallel to this is the second deduction from the diary.
The phrases Beckmann used to describe America are
similar to those we find in the parable of the Prodigal Son,
who also went away into a distant land and 'lost' himself.

At the end of the First World War, Beckmann had drawn six gouaches on this theme, and his model for the Prodigal was himself. Now he returned to it in *The Prodigal Son*, 1949. This time, the Prodigal, as is right, is very unlike Beckmann, a wretched youth with slit eyes and a thin nose. He is the image of a wasted life, dissipation personified. As he slumps in self-pity (that emotion Beckmann scorned), predatory women thrust their breasts at him and insist on emotional response. He is trapped, as empty as the wine glasses on the table, as debilitated as the great flaring tulips at his back are alive. This is very unlike the artist in every way. Yet, jutting out uncannily from the right of the painting, seemingly enthroned on an immense pink settle, is a giant head. Commentators have debated its meaning, but might it not be the head of the mature Beckmann? That forcefully protruding chin is eerily familiar, and so are the hooded eyes and the great prow of a nose. Perhaps he is here as witness. This is a 'road not travelled': the young Beckmann resisted the allurements of the flesh, though some of his work suggests that he did so with difficulty. He saw 'art, love, passion' as closely linked, but he had steeled his spirit not to waste itself. The despondent Prodigal is the self-portrait that might have been. The monolithic crag of Beckmann's face silently acknowledges this.

The stern remoteness of Beckmann's profile in *Prodigal Son* recalls one of his nightmare/dreams:

> Saw my paintings radiating in distant gods in dark night [sic]. But – was it still I? – no – far from me, my poor self, they circled as independent beings who scornfully looked down on me, 'that we are' and 'You n'existe plus' – oho – battle of the self-born gods against their inventor? – Well, I must bear that, too – whether you will or no – until beyond the great partition – then perhaps I will be myself and 'dance the dance' of the gods – outside my will and outside my imagination – and *still I myself*.[25]

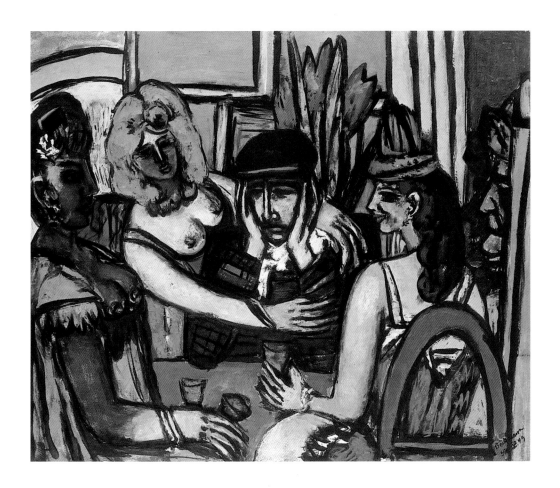

The Prodigal Son, 1949

The grammar here is odd, with its switches of person, now
first, now second, shifting in dream fashion from one scene
to another, referring with such ambiguity to the 'gods'.
Yet, this was at the heart of all Beckmann did, this longing
to transcend himself and still be himself, to enter 'beyond
the great partition'. This partition seems to have become
steadily less solid, less of a genuine barrier, as he became
more and more conscious of spiritually 'getting there'.
Since we still do not know, he said, 'just what this "I" really
is, this ego, which forms you and me, each in his own
fashion, must pursue its discovery with greater intensity....

Still Life with Yellow Roses, 1937

What are you? What am I? These are the questions that incessantly hound and torment me, …'. Then he added, 'but which also perhaps contribute to my artistic efforts'.[26] In general, we could say these questions are the underlying theme of his art, that which gives it its power. 'Subject', as he claimed, did not matter all that much. Whatever Beckmann treated would have this undertone of the serious, the eternal. Yet, gravity is not solemnity: there is infinite delight in Beckmann's paintings. Think only of *Still Life with Yellow Roses*, 1937, so radiant in its abundance that we can hardly distinguish forms, or the glorious *Nude in Studio*, 1946, in which he plays off the sensual abandon of the woman against the dark muscularity of the man. But the man is a statue, his torso is mutilated, and we recognise,

Nude in Studio, 1946

in that huge nose, the familiar face of the artist. There are layers of meaning in both of these paintings, but the immediate effect is of intense pleasure. Beckmann was a master of colour as well as of form, and he made the two sing in harmony, to his tune.

America, with its acceptance and admiration ('[I] was applauded – oh God, people clapped when Herr Beckmann stood up …', he wrote in humorous wonder),[27] seems to have drawn from him the most luxuriant and yet focused of his later canvases. He and Quappi had often stood together in masquerade. Now perhaps they joined once more, but so masked, so alien, that they are unrecognisable in *Masquerade*, 1948. If this painting does depict them, it is a final admission that disguise enervates. The cat-woman has a stuffed bosom; the clown man is overmuscled for the club he carries. The woman sags, wearily; the man holds himself in hesitant readiness. Although they meet across a skull, each has concealed the reality of his or her own head, defying death and yet playing with it. As ever, the partners are apart, joined only by their proximity. This painting is beautiful but disturbing. We feel that Beckmann had a great longing to throw away all subterfuge, to reveal the self that he had finally discovered.

His last painted self-portrait, executed in 1950 (p. 81) – he was to die suddenly from a heart attack that same year – seems an anti-climax. There are no heroics here, and no brooding over fatality. This Beckmann has lost weight and, most arrestingly, has gone American in his dress. Disregarded are the gentlemanly black-and-whites: he wears casual clothes with daring colour contrasts. It is a much smaller head we see, a much more ordinary head, and for once he actually smokes that wizard's wand, his cigarette. He looks unburned, relaxed in his studio, pausing after work to evaluate something just finished. For all its relative mildness, this is a very strong self-portrait.

Masquerade, 1948

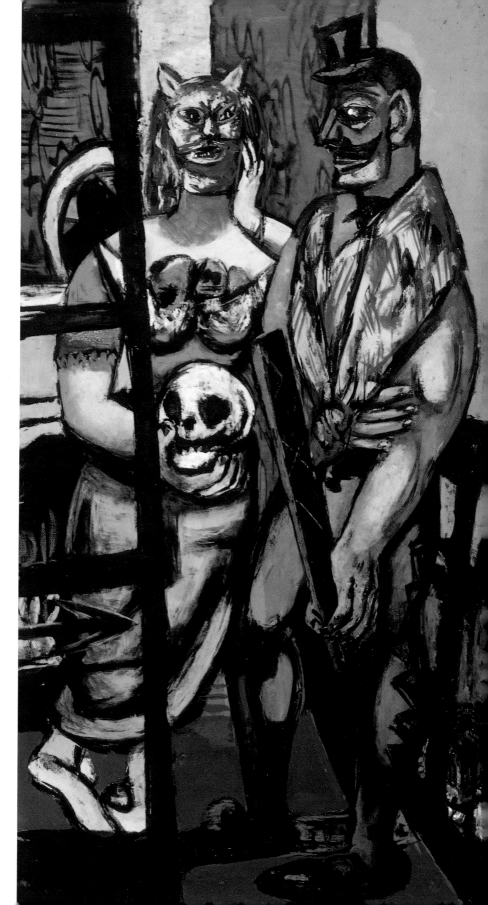

Beckmann has captured every part of himself with a thick black line, tying it into place, letting nothing slip. He has seized upon the arm of the chair, too, almost insolently isolating it from its background, claiming it for his own. It is what we would expect: a ship in harbour, after its storm-tossed voyaging, but not adrift. The ropes are furled, and the artist contemplates what is to be done with what he has struggled to achieve. This is not, of course, material wealth or success, though he knew something of both in these transatlantic years. His achievement is an inner one, that 'own self that we are all in search of'.

Perhaps we should parallel this tranquil self-portrait with a species of alter ego? Beckmann was always conscious of the man/woman dichotomy, two such different ways of being human. He credited women with just as much primal force as men; indeed, women sometimes seemed the stronger of the two, but, if equals, they were somehow still competitors. His pairs struggle, reject, entice, damage each other. It is not only Siegmund and Sieglinde, Brother and Sister who thrust a sword between themselves. His rage at 'sentimentality', which he said he 'loathed', his distrust of emotions – 'tears are for slaves' – all this makes one wonder if he was afraid of the gentler side of his nature, his anima, his inner woman. If so, there is a pleasing rightness in his last self-portrait showing a woman-like gentleness, while his last female portrait is Beckmann-like in its powerful presence. *Carnival Mask, Green, Violet and Pink, Columbine*, 1950 (p. 83), splays a woman across the canvas with unprecedented power. She dominates, recalling very vividly the force of *Self-Portrait in Tuxedo*, 1927, or *Self-Portrait with Horn*, 1938. In her huge impenetrability, she even reminds us of that climactic achievement in Amsterdam, the 1944 *Self-Portrait in Black*. The critical difference is that Columbine is unashamedly sexual, whereas Beckmann's natural reticence kept him

Self-Portrait in Blue Jacket, 1950

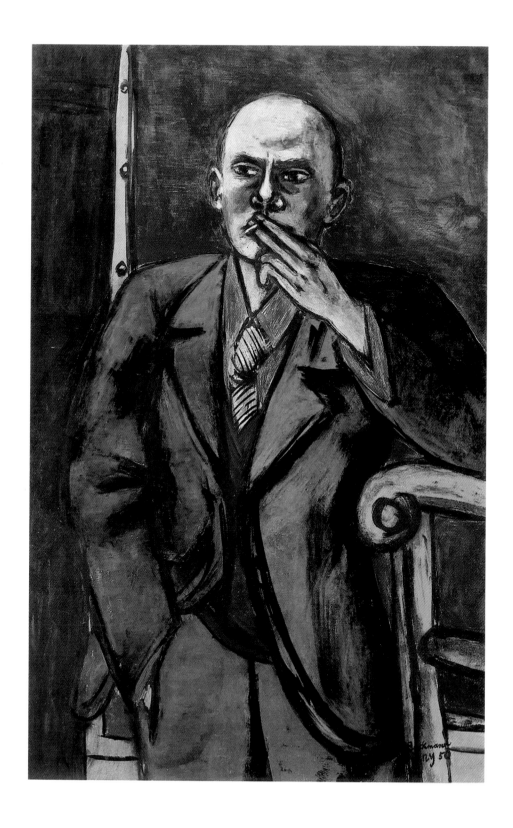

from ever introducing a sexual element into a self-portrait. Columbine sprawls like a giant Venus, her discarded lovers scattered before her, her throne curtained and apart. She is not, strangely enough, an evil figure. She is natural instinct, destructive, cruel, impossible to understand or predict, innocent, marvellously beautiful. She could be seen as Beckmann's final acceptance of much in his art – perhaps even in his life? – that he had rejected. In painting Columbine with such passionate admiration, he made his peace with the demon.

This glorious and celebratory icon was not Beckmann's last painting. That was left unfinished, and, with a delightful aptness, it contains his least observable self-portrait. Despite his failing health, the sheer extent of America coaxed him into making a seventh (*Argonauts*, 1949–50, p. 84), an eighth (*The Beginning*, 1946–49, p. 85) and now a final ninth triptych. This last was to be an all-woman painting, called either *Ballet Rehearsal* or *Amazons* (pp. 86–87), and Beckmann's death in 1950 left it finished in all but the actual application of paint. It remains a drawing, with charcoal and coloured chalk. This triptych is more playful than any that went before; Beckmann confirmed to his wife that it was to be 'humorous and gay'.[28] The self-portrait is in the right panel, where two young women limber up for the challenges of adult life. We are given to think that these challenges will be primarily sexual: despite the acceptance of himself-as-woman in Columbine (to rather overstate the case), Beckmann remained a man of his generation, a male chauvinist. But the Amazon girls are very charming. One fears the coming encounters and protects herself behind a lance. The other girl is far more open to life. Even as she dresses, she watches, peeping in her mirror, where, enormous in his presence, she sees not Beckmann but Beckmann reflected in another mirror behind her on the wall. The looking

Carnival Mask, Green, Violet and Pink, Columbine, 1950

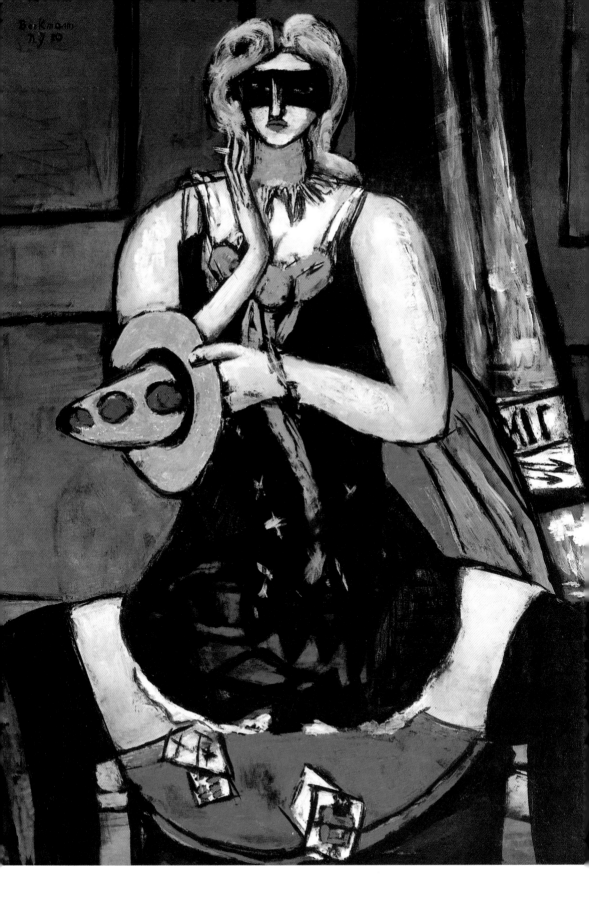

glass, in which we are both present and not present, both real and unreal, held a continual fascination for Beckmann. He used it as a symbol all his life, to express his conviction of not belonging, of not being able to trust the truth of what one saw. There was something magical about mirrors, as there was about candles, able to illuminate only if burnt away themselves, or about the carnival, where playing a part can set the Self free. The girl in *Amazons* cannot see the 'real' Beckmann in her tiny mirror, only what she can accept of him, and he is too large (too human?) even to be encompassed by the large mirror. It captures only a fragment of his face, with one staring Cyclopean eye. He is removed from the Amazon world, the onlooker who paints it for us. For Amazons, he was the Other.

Argonauts, 1949–50

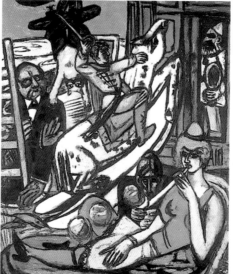

The Beginning, 1946–49

This was always how he saw himself. It is less notice-able in his specific self-portraits than in the other forms in which this most self-obsessed (in its purest form) of artists painted himself. It represents a pure self-seeking because it was for a non-self-serving end. Beckmann spoke of the task he had undertaken, the duty 'to find the self in animals and men, the heaven and hell which together form the world in which we live',[29] and this may well have been true. But the dominant impression is always of a need to find this self in himself, even if, noble-hearted as he un-doubtedly was, it was to serve for the general betterment. Again and again, we find in the paintings Beckmannesque images that are often more revealing of his inner life than the formal 'Beckmanns' are.

The tensions of the war years are revealed obliquely, in a way that the artist's sense of privacy would have rejected if stated directly, in the 1941–42 triptych, *Actors* (pp. 88–

89). The central panel is unpleasantly crowded: actors jam together on too small a stage, pressing in from the wings, jostling for space in the centre. It is probably a perfect parallel to how Beckmann felt. Worse still, there are crimes being committed under the floorboards; there are rejects waiting sadly where an audience should be, a despondent child and her cat. The main actor is harassed, not just by the noises off, but by the prompters and the actress who

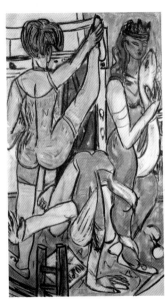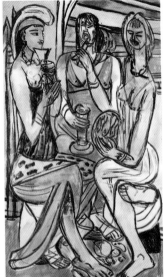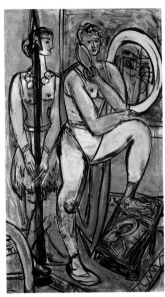

freezes in mid-song. Worst of all, he is conscious of a sinister dwarf, encroaching on his activity and yet bearing a dreadful facial likeness to him. Both dwarf and hero-king – as elsewhere in Beckmann – are alter egos of the artist. Here, as actor, the king commits suicide. This is a gesture of despair that the real Beckmann would not allow himself. It must have given him great artistic satisfaction to expurgate these emotions that could not be openly

Ballet Rehearsal or *Amazons*, 1950

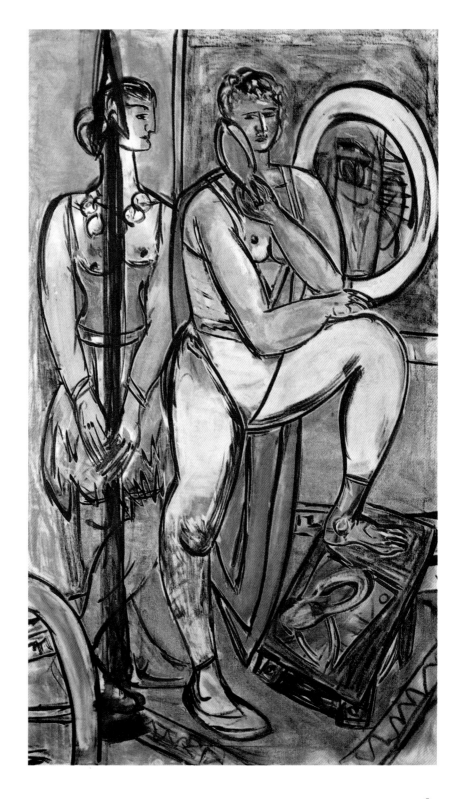

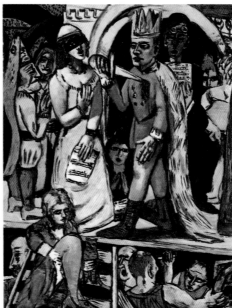

Actors, 1941–42

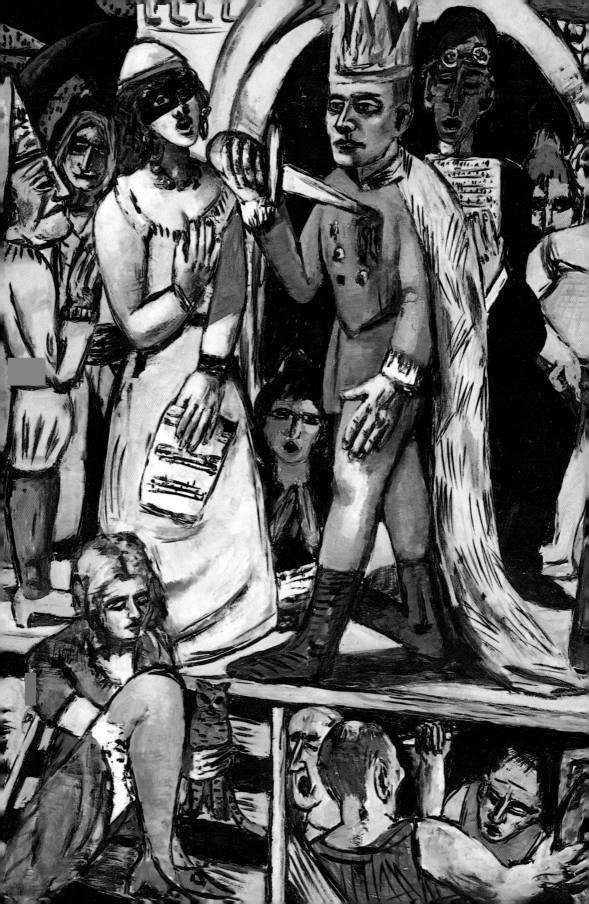

acknowledged, to mock his dwarfish possibilities and destroy his self-pity. As a painting, *Actors* is not fully successful, but he laboured long on it and used it as a catharsis.

There may be another catharsis in an earlier work: *Warrior and Birdwoman*, 1939. Beckmann was attracted to mythology, as both a poet and a painter, and in his diaries sometimes refers to himself as Odysseus, though he rarely made use of the image in visual terms. He preferred, in fact, to give a feel of mythology, to recall its mystery, rather than tie himself down to any specific story. This sets the viewer's imagination free to wander, to sense hidden layers, to share his poetry more creatively. In this painting, the suggestions are mainly concerned with the Birdwoman. Is she a Siren, one of the seducers whose tempting song Odysseus had to resist, whatever the cost? She droops before the Beckmann-figure, grounded, tempting no one. Or is she Siren as denizen of the Underworld, where some myths hold that the song of seduction could be enjoyed, since all response was safely behind one? Yet, she stands in the Beckmann-figure's path as if to threaten. Behind her is a darkly feathered apparition, male it would seem, which joins her in warding off the advancing Beckmann. He is helmeted and masked – only the nose and chin betray his identity. He has a lance, shooting across the canvas in a fierce diagonal, and a sword, cutting down from the opposite direction, yet he holds both very lightly. He does not challenge his otherworldly opponents; he turns away, almost contemptuously, striding onwards without hesitation. He seems confident of his course, its rightness and its direction, something Beckmann himself must have longed to be. The nebulous enemies of 1939 would flesh themselves out as his exile lengthened, but he was already giving shape to his resolve. He would be a Hero, a Warrior, however masked.

Warrior and Birdwoman, 1939

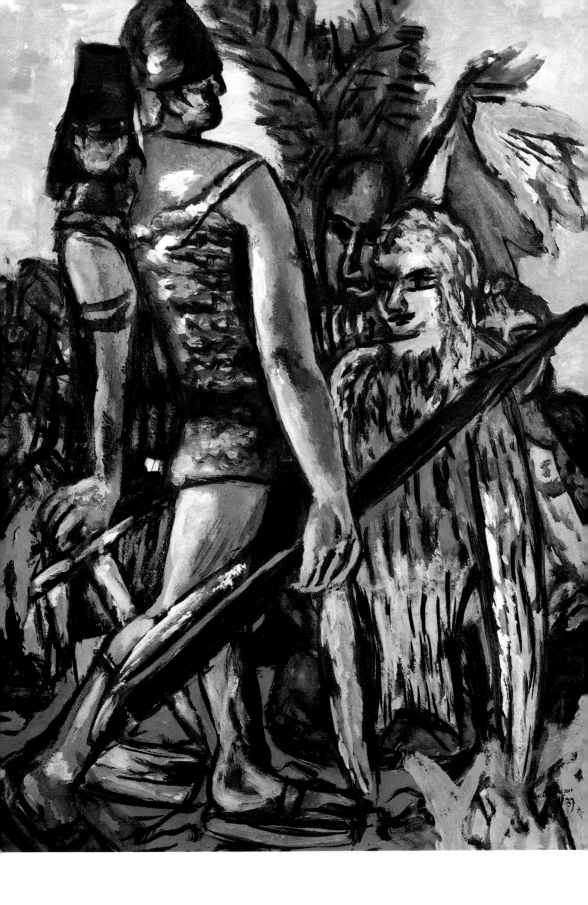

*"It is important and, really, probably
the most important thing of all to remember
that a work of art must speak the truth"*

In all his 'alter egos', we can, if we look carefully, see Beck-
mann, even a hidden Beckmann. Yet, it could be that his
most expressive alter ego did not take human form, that it
was not to be seen but sensed, emotionally experienced.
This was the symbol of the fish, profoundly important to
him, found everywhere in his art. The fish reigns majestic-
ally over still lifes; it leaps frantically in the background of
torture scenes or flaps, exhausted, on the floor. It skips
happily in the hero's net, peers from the waters of mytho-
logies, entwines itself with Death, lies on the dishes of
beautiful women and is carried to their mouths. The fish is
an ancient symbol. It is incised on the walls of the Cata-
combs, a code for Christ, because the early Christians had
seen that the initials of *Jesus Christ, Son of God, Saviour*

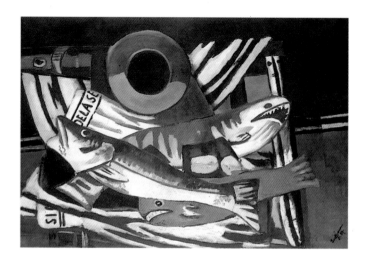

Large Still Life with Fish, 1927

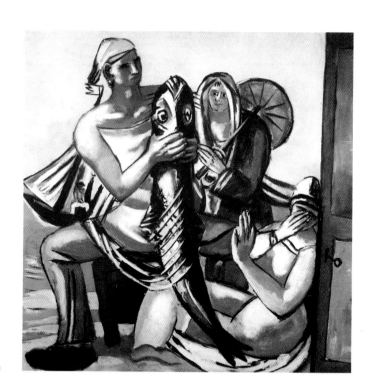

The Catfish, 1929

spelt out *icthus*, the Greek word for 'fish'. The Gnostics,
proponents of a religious philosophy that Beckmann
studied with care, saw the fish as embodying the eternal
surge of the spirit upwards, its freedom, its power. For the
pagans, the fish stood for male sexuality, slippery and
dominant. When the art historian W. R. Valentiner asked
Beckmann to explain what he meant by the fish, he is said
to have replied, 'half serious, half satirical', 'that man origin-
ated in the sea and that we all derive from the fishes, that
every male still has something of a particular fish about
him'.[30] This sounds more satirical than serious, the kind of
satirical jest we use when a nerve is touched by a question.
Sometimes, Beckmann's fish are small, swimming lightly
to the king in *Departure* or fitting easily into the women's
hands in *Amazons*. But more often, they are strong, muscu-

lar creatures, their impassive heads with large fixed eyes irresistibly recalling the presence of Beckmann himself. They are less victims than accomplices, as in *Fisherwomen*, 1948, one of his most sensuous paintings, in which the women hold fish to their breasts or to their lips. The pink bodies of these sensuous women curve in a triumphant celebration of bodily beauty. The transparent glass of the vase, protecting some exotic flower, tomblike in its shape and function, is also transparent, focusing on the soft curves of the women's buttocks as if to emphasise them for us. The fish, which must by definition be dead, nonetheless seem responsive to their partners. Fish, in mythology, are part body and part spirit, of this world but at home in another dimension. All this is richly evocative of Beckmann himself and his belief in 'more than this life only', as he wrote to his wife. It is easy to read *Fisherwomen* as a mating picture, and indeed Beckmann himself told Quappi that the women were fishing for husbands, lasting partners and complementaries.[31] In this refined sense, 'mating' is correct: the painting celebrates a fulfilment.

But there seem to be layers beneath layers in all of Beckmann's major works. He had said:

> What I want to show in my work is the idea which hides itself behind so-called reality. I am seeking for the bridge which leads from the visible to the invisible, like the famous cabbalist who once said: 'If you wish to get hold of the invisible, you must penetrate as deeply as possible into the visible.' To penetrate is to go through.[32]

However sumptuous his depiction of the visible, Beckmann's attention was fixed on the beyond. The fish, that creature that we cannot approach live except at a distance, expressed his deepest mind here. *Journey on the Fish*, 1934 (p. 97), may be his clearest illustration of this. A man and a woman have bound themselves to a pair of gigantic fish.

Fisherwomen, 1948

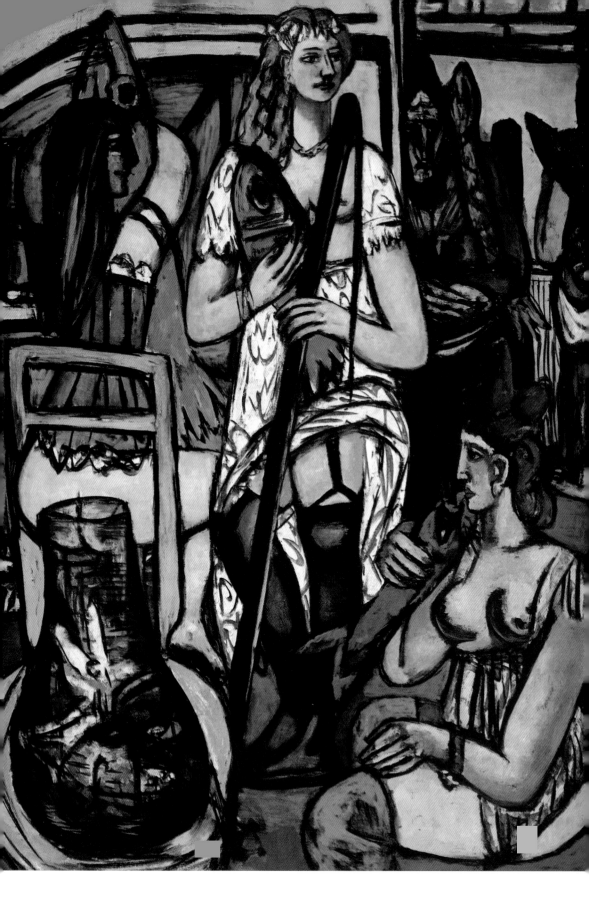

He lies face down; she sits curled on the creature's broad back. To take this journey, each has removed a mask, surrendering it to the other. She holds the large Beckmann mask, he holds the tender disguise of his beloved, far more vital in her true self than in the conformist mask. The masks are black, unemphatic, but the faces, though we cannot see his, are powerfully beautiful. The fish, apparently male and female, soar upwards and plunge precipitously into the darkness beneath. To their wisdom the human pair have entrusted themselves, and the pervasive air of serious joy indicates that the fearsome journey into mystery is not a venture into death, but into a new form of life.

Here, Beckmann was almost rephrasing the biblical advice to lose one's soul in order to save it. Mystical tradition has always seen three stages in the journey to Truth. The first involves Purification, a horrendous stripping of the self from its illusions. That, we might agree, is what Beckmann suffered in the First World War. He went into it a happy egoist; he came out sobered, shaken, adrift from his certainties. After the consolidation that follows from being purified, the soul comes to Illumination. Here again, we see a parallel, as Beckmann learned to evaluate what really mattered to him under the whip of Nazi rejection. The final stage is Union, that moral harmony wherein all desires come together in singleness of purpose, the spirit 'knows', rests on the Beloved, and all anxious fretting ceases. The last great portraits, especially *Self-Portrait in Black* of 1944, suggest that Beckmann had found that he had reached some sort of goal, some interior becoming. Yet, this theory presupposes that one has a self to begin with, an identity with which to endure the purgation, receive the illumination, enter the bliss of union. Beckmann's problem was that he could not be certain that this integral self was there at all. It was to feel real, to know he existed, to find some spark of indestructible (eternal?) life within

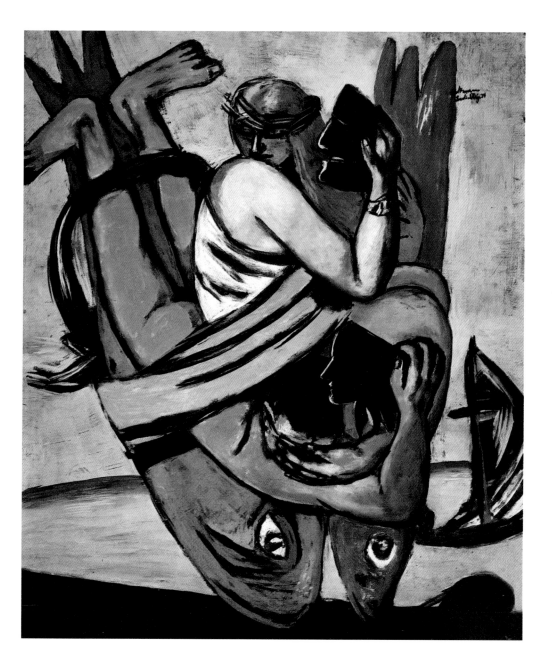

Journey on the Fish, 1934

that drove him forward. Writing to his first wife, Minna, about her operatic career, he told her: 'I am so happy that you have the opportunity to let your lovely voice be heard. [In an orchestral context, he might have written much the same encouragement to Quappi, his second wife, a professional violinist.] And happy that you are able to feel even

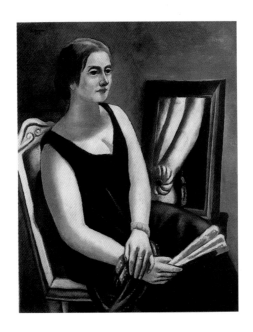

Portrait of Minna Beckmann-Tube, 1924

more yourself, since, after all, that's what art amounts to. Self-gratification. Naturally in its highest form. Sensations of existence.'[33] This is in the end what Beckmann wanted from art: a sense of his existence. This was pure gratification, a means of achieving one's own self and having the rapture of knowing it. He shares this rapture with us. If Beckmann sought for his self with infinite care and skill, he set us free to experience in his work the meaning of our own selves. The artist's fish carries humanity on its back.

Quappi in Blue, 1926

Quappi in Blue and Grey, 1944

Biographical Notes

Self-Portrait with Cigarette, 1947

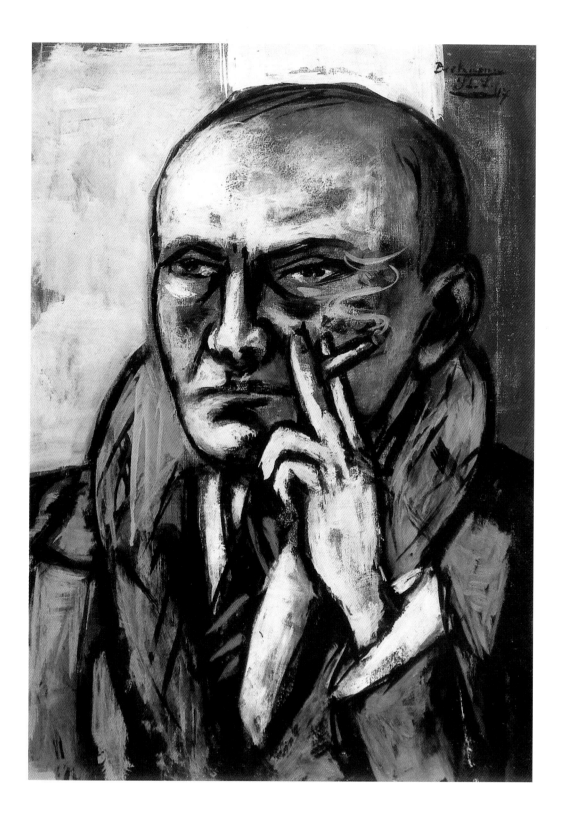

1884

Max Beckmann is born in Leipzig on 12 February, the youngest of three children. His father, Carl Heinrich Christian Beckmann, was a flour merchant; his mother, Antoinette Henriette Bertha, *née* Düber, comes from a wealthy farming family in Königslutter, near Brunswick. His brother Richard is ten when he is born, and his sister Margarethe fifteen.

1892–94

Beckmann temporarily stays with his sister, Margarethe, in Falkenburg in Pomerania, and attends school there.

1894

Death of his father. His mother movest to Brunswick with her two sons to stay with relatives. Until 1899, Max Beckmann attends school in Brunswick and Königslutter, and boarding-school in Gandersheim, and starts to draw while still at school.

1899

Entrance examination for the Academy in Dresden. Beckmann is rejected because, instead of simply making a drawing of the plaster cast of a *Venus*, he produces his own composition with details in the background.

1900

Admission in June for a probationary period at the Grossherzogliche Kunstschule in Weimar; on 10 October, Beckmann is finally acceptec to the Classical course given by Otto Rasch.

1901

Beginning of a lifelong friendship with Ugi Battenberg, a fellow student in the Nature course given by the Norwegian portrait and genre painter Frithjof Smith.

Beckmann with his brother Richard and sister Margarethe, 1898

Beckmann (seated at left) at the Grossherzogliche Kunstschule in Weimar, 1901/02

Beckmann adopts Smith's method of making preparatory sketches directly onto canvas with charcoal.

1902
At a carnival party at the Kunstschule in Weimar, Beckmann meets his future wife, Minna Tube, daughter of an army pastor. She has been studying at the same college since 21 October, taking the 'Ladies' Course' taught by Hans Olde .

1903–04
After the summer semester of 1903, Beckmann finishes his studies at the Academy in Weimar. He moves to Paris and rents a studio there. The work of Paul Cézanne makes a powerful impression on him.
At the end of March 1904, he travels to Geneva via Fontainebleau and Colmar, continuing from there via Frankfurt to Berlin.

1905
Summer visit to the north-west coast of Denmark, where he produces numerous beach and marine landscapes.
Beckmann paints *Young Men by the Sea*, and numbers the painting '1' in the catalogue of works which he now begins. For the first time, he signs the painting with his dedicatory monogram to Minna Tube, 'HBSL' ('Herr Beckmann seiner Liebsten', Mr. Beckmann to his darling). He continues using this signature until 1913.

Beckmann at Vietzkerstrand at the Baltic Sea, 1907

1906
Beckmann takes part in the third exhibition of the Deutscher Künstlerbund (German Artists' Association) in Weimar, where he receives the Prize of Honour for *Young Men by the Sea*, which includes a scholarship to study in Florence. The painting is purchased by the Weimar Museum. Death of his mother from cancer during the summer. Beckmann paints *Large Death Scene* and *Small Death Scene*.
Marriage to Minna Tube on 21 September; honeymoon in Paris.

1907
Stays in Florence from November 1906 to spring 1907; produces *Self-Portrait in Florence*. He takes part in the 'First German National Art Exhibition' in Düsseldorf, and in exhibitions in Berlin at the Berlin Secession and at the Paul Cassirer's gallery.

Builds a house in Hermsdorf, Berlin, designed by Minna Beckmann-Tube.

1908
Birth of his son Peter on 31 August.
Takes part in exhibitions at the Berlin Secession, at Paul Cassirer's gallery, and the Great Exhibition of Art at the Kunstpalast in Dresden. Plans for the founding of a 'New Secession'.

1909
Meets the art critic Julius Meier-Graefe, who visits him at his studio.
One of Beckmann's paintings is included in the International Art Exhibition at the Glaspalast in Munich, and he exhibits for the first time at the Salon d'Automne in the Grand Palais, Paris.
Produces *Double Portrait: Max Beckmann and Minna Beckmann-Tube* and *Scene from the Destruction of Messina*.

1910–11
Beckmann is elected to the board of the Berlin Secession, as its youngest member, but resigns after only six months.
Takes part in exhibitions in Berlin, Bremen, Darmstadt, Dresden, Leipzig, and Munich.
In Berlin, Beckmann establishes contact with Israel Ber Neumann, who publishes his graphic work.

1912
First meeting with the Munich publisher Reinhard Piper, at Beckmann's studio in Hermsdorf.
In the journal *Pan*, Beckmann publishes 'Thoughts on Timely and Untimely Art', a response to Franz Marc's essay 'The New Painting', in which Beckmann rejects the modern formalism of the Blue Rider group.
First one-man exhibition at the Kunstverein in Magdeburg and at the Grossherzogliches Museum für Kunst und Kunstgewerbe in Weimar.

The Beckmanns' house in Hermsdorf, Berlin 1908

1913
The first monograph on Max Beckmann, by Hans Kaiser, is published by Cassirer to accompany the Beckmann retrospective, presenting 47 paintings at Paul Cassirer's gallery in Berlin (January to February).
In January, the first exhibition in the USA to include Beckmann's work, 'Contemporary German Graphic Art' is held at The Art Institute in Chicago.

Beckmann in Hamburg, 1913

At the 26th Berlin Secession, the *Sinking of the Titanic* (1912) and *Portrait of the Simms Family* (1913) are shown. Resigns from the Berlin Secession.

1914
Founding of the 'Free Secession' in Berlin. Beckmann is elected to its board.
After the outbreak of the war, Beckmann becomes a volunteer medical orderly in East Prussia. His brother-in-law, Martin Tube, dies on the front in September. Returns to Berlin in the autumn.

1915
Beckmann volunteers for service in the medical corps in Belgium. Travels to Lille, Brussels, Ghent, and Ostende, where he meets Erich Heckel, who is also serving in the medical corps. He is commissioned to illustrate the military songbook for the 15th Army Corps, which is published by Cassirer in Berlin, with 13 ink drawings.

After a physical and a psychological breakdown during the summer, Beckmann is transferred to Strasbourg, and sent on leave in October. He goes to Frankfurt am Main, where his friends Ugi and Fridel Battenberg take him in and set up a studio for him. In Strasbourg, he paints *Self-Portrait as Medical Orderly*.

1916
Beckmann's *War Letters* are published in book form by Bruno Cassirer.
In November, applies for a professorship at the Academy in Dresden; however, Ludwig von Hoffmann receives the post.

1917
Beckmann is officially released from military service.
In Berlin, Neumann organizes the only one-man exhibition of Max Beckmann's work held during the war.

Beckmann as a medical orderly (last row, fourth from left), 1915

Beckmann in Frankfurt, c. 1917

1918
Begins work on *The Night* in
August.
Minna Beckmann-Tube receives
an engagement in an opera
production in Graz, Austria.

1919
Hell, ten lithographs with a title
page, is published by I. B. Neu-
mann in Berlin. Beckmann de-
clines the offer of a position to
teach a course on nudes at the
College of Fine Arts in Weimar.
He becomes a founding member
of the Darmstadt Secession,
headed by Kasimir Edschmid.

1920
Beckmann writes two plays, *The
Hotel*, first performed in Munich
in 1984, and *Ebbi* (published in
1924).

First contract with the art dealer I. B. Neumann in Berlin for the sale of paintings.

1921
Beckmann paints *Self-Portrait as Clown*.

1922
During this and the following year, Beckmann produces over 90 etchings, woodcuts and lithographs, almost one-third of his entire graphic work.

1923
I. B. Neumann moves to New York, and transfers the running of his graphics gallery in Munich to Günther Franke.

1924
In Vienna during the spring, Beckmann meets Mathilde von Kaulbach, the youngest daughter of the painter August Friedrich von Kaulbach. A music student, she is living with the Motesiczky family, where she is given the nickname 'Quappi'. Signs contract with Peter Zingler in Frankfurt and Paul Cassirer in Berlin. A monograph on Beckmann is published by Piper in Munich, with essays by Glaser, Meier-Graefe, Hausenstein, and Fraenger.

1925
Mutually agreed divorce from Minna Beckmann-Tube. Engagement to Mathilde von Kaulbach, who declines an offer from the State Opera in Dresden on Beckmann's account.

Mathilde ("Quappi") Beckmann, 1925

They are married in Munich on 1 September. Journey to Italy. A contract with Neumann guarantees Beckmann an annual income of 10,000 marks. The couple live in the Hotel Monopol-Metropol, opposite the main railway station in Frankfurt, until May 1926. Beckmann's work is one of the main emphases in the 'New Objectivity' (*Neue Sachlichkeit*) exhibition in the Städtische Kunsthalle in Mannheim (June–September).
In October, Beckmann is appointed for a period of five years to teach a master class at the combined Städelschule-Kunstgewerbeschule.

1926

Death of his brother Richard.
In April, I. B. Neumann organizes the first one-man exhibition of Beckmann's work in the USA at his gallery in New York.

Beckmann and Quappi in Baden-Baden, 1929

1927

On the occasion of Meier-Graefe's sixthies birthday, the painting *The Bark* (1926) is presented to the Nationalgalerie, Berlin by art patrons. It is Beckmann's first work at the gallery. Beckmann's essay 'The Artist in the State' is published in the journal *Europäische Revue.*

1928

Beckmann receives the Imperial Prize for German Art, 1928, also awarded to Max Liebermann, Max Slevogt, Ernst-Ludwig Kirchner, and Heckel.
The Nationalgalerie in Berlin purchases *Self-Portrait in Tuxedo* (1927).

1929

Together with Richard Scheibe, Jakob Nußbaum, and Reinhold Ewald, Beckmann receives the Honorary Prize of the City of Frankfurt. However, he does not receive the title 'Professor', applied for by the municipal authorities in Frankfurt. Between 1929 and 1932, Beckmann lives in Paris from September to May every year, travelling to the Städelschule in Frankfurt for one week each month to carry out his teaching duties.

1930

The City of Frankfurt extends Beckmann's contract until 1935, although he is now mostly working in Paris.
Six of Beckmann's paintings are shown at the Venice Biennale.

Beckmann in his studio in Amsterdam, 1938

Beckmann in Amsterdam, 1938

1931

Disagreements with the Director, Fritz Wichert, over his rare appearances at the Städelschule; on 26 October Beckmann gives in his notice, but is persuaded to stay on by Landmann, the city's mayor, Michel, the head of the city's cultural department, and Prof. Swarzenski. His one-man exhibition at the Galerie de la Renaissance in Paris is warmly received by the press. In *Le Figaro*, Beckmann is described as the 'Picasso germanique'. The Nazi press, by contrast, attacks him on the grounds that the exhibition presents a bad example of German art.

1932

First meeting with Erhard Göpel, later one of the founders of the Beckmann Society, and together with his wife Barbara initiator of the catalogue of Beckmann's paintings.

At the Nationalgalerie in Berlin, Ludwig Justi installs a Beckmann room, including ten paintings. Increasing political pressure and the economic crisis force Beckmann to give up his studio and home in Paris. He declines the offer of an appointment at the Academy of Fine Arts in Munich.

Flechtheim cancels the contract with Beckmann and I. B. Neumann.

1933
The Beckmanns move to Berlin.
After Hitler's seizure of power,
Wichert, the Director of the
Städelschule, is suspended, and
Beckmann is dismissed along
with Baumeister, Scheibe, and
Nussbaum. The Beckmann
room at the Nationalgalerie in
Berlin is dismantled after the
dismissal of Ludwig Justi, and
the opening of a Beckmann ex-
hibition at the Museum in Erfurt
is forbidden.
In the summer, Beckmann stays
in Ohlstadt, Upper Bavaria.

1934
Only one article is published on
the occasion of Beckmann's 50th
birthday, by Erhard Göpel in the
Leipziger Neueste Nachrichten.

1936
Travels to Paris with Stephan
Lackner and his father Sieg-
mund Morgenroth, to investigate
ways of emigrating to the USA.
The last one-man exhibition of
Beckmann's work in Germany

until 1946 is shown at the Kunst-
kabinett in Hamburg.

1937
After hearing Hitler's speech at
the opening of the 'Haus der
Deutschen Kunst' in Munich,
Beckmann and his wife leave
Germany on 19 July, the day of
the opening of the 'Entartete
Kunst' (Degenerate Art) ex-
hibition, which includes ten
paintings and twelve graphic
works by Beckmann. A total of
590 of his works in German
museums are confiscated.
The art historian Dr. Hans Jaffé,
whom Beckmann knew in Berlin
and who had emigrated to Am-
sterdam ahead of him, provides
accomodation and a studio for
him there.
In Amsterdam, he paints the
self-portrait *The Liberated One.*

1938
At the opening of the 'Exhibition
of 20th-Century German Art' in
London, intended as a counter-
exhibition to the Munich Dege-
nerate Art exhibition (and with
patrons including Le Corbusier,
Aristide Maillol, and Pablo
Picasso), Beckmann gives his
now famous speech 'On My
Painting'.
In October, the Beckmanns
move to Paris, although they
keep the apartment in Amster-
dam. Some of the works of art
confiscated from German
museums are offered for sale on
foreign-currency terms to a
small group of art dealers in

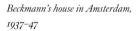

Beckmann's house in Amsterdam,
1937–47

Germany. Karl Buchholz, and later Günther Franke, purchase several paintings, which are not allowed to be shown in public.

1939
Beckmann receives a French passport and intends to move to Paris. However, he has to abandon the plan due to the imminent threat of war.
He receives the first prize at the 'Golden Gate Exhibition of Contemporary Art' in San Francisco for his triptych *Temptation*.

1940
Beckmann receives an offer to give a summer course at The Art Institute of Chicago. However, the American Consulate-General in The Hague refuses to give him a visa due to the impending entry of the United States into the war.
Invasion of the Netherlands by German troops on 10 May. Max and Quappi burn the diaries the have been keeping since 1925.

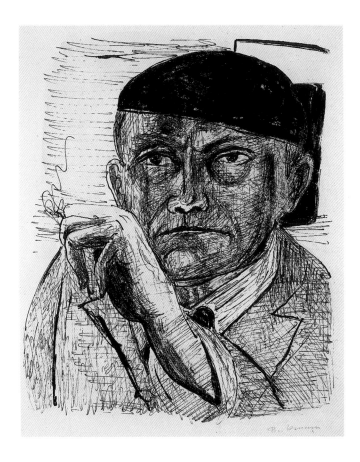

Self-Portrait, 1946, Lithograph

Since Lackner is no longer able to make payments, the Beckmanns' financial situation deteriorates.

1942
In June, Beckmann receives a notice of conscription from the German army, but is declared unfit for service due to his heart condition.
The Museum of Modern Art in New York purchases the triptych *Departure* (1932–35).

1943
In February, Helmuth Lütjens takes most of Beckmanns's paintings into his house to protect them from potential confiscation by the German occupation forces. Beckmann paints the triptych *Carnival*.

1944
In February, Beckmann contracts pneumonia. He is conscripted once again, but classed as permanently unfit for service.

Beckmann in front of his triptych Departure, New York, 1947

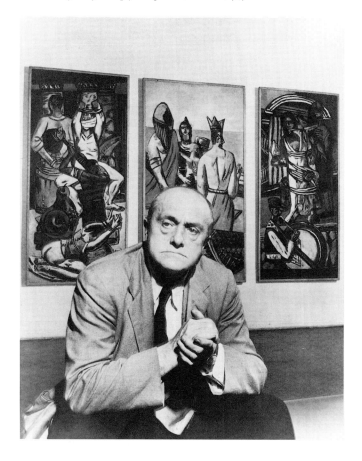

With the landing of Allied troops in Normandy on 6 July, living conditions become more difficult. The couple's links with Germany are severed. Beckmann paints *Self-Portrait in Black*.

1945
The Allies enter Amsterdam on 4 May. Beckmann resumes contact with his friends abroad.

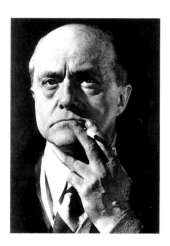

Beckmann in New York, 1949

1946
In August, Beckmann is accorded 'non-enemy' status, removing the danger of his being expelled from the Netherlands. Beckmann refuses offers of appointments at the Academy of Fine Arts in Munich and in Darmstadt (the directorship of what later became the Werkkunstschule).
In Germany, Beckmann's work is acknowledged for the first time after the war with one-man exhibitions in Bad Nauheim, Stuttgart, and Munich.

1947
Beckmann declines an offer of an appointment at the College of Fine Arts in Berlin. In March, he travels abroad for the first time after the war (to Nice). Beckmann accepts an offer from the Art School at Washington University in St Louis, Missouri, of a temporary professorship during the absence of Philip Guston.
On 19 August he leaves Rotterdam for New York on the same

ship as Thomas Mann. Reunion in New York with old friends from Berlin and Frankfurt. On their first evening, Ludwig Mies van der Rohe gives the Beckmanns a tour of the city. As a member of the jury for the 'Seventh Annual Missouri Exhibition' in St Louis, Beckmann favours the inclusion of abstract and surrealist paintings, causing a stir and criticism in the press.

1948
In May, opening of the largest retrospective of his work to date in America, at the City Art Museum in St Louis.
On 5 October, Beckmann and his wife apply for American citizenship.

1949
In the summer, Beckmann teaches at the Art School of the University of Colorado, Boulder. At the end of September, begins teaching at the Brooklyn Museum Art School.

1950
The contract with the Brooklyn Museum Art School is extended for six years.
Fourteen of Beckmann's paintings are shown at the Venice Biennale, and he receives the Conte Volpin Prize for foreign artists.
He paints his last self-portrait, the *Self-Portrait in Blue Jacket*. Travels to St Louis to receive an honorary doctorate from the city's Washington University on

6 June. Due to the Korean crisis, a planned trip to Europe is abandoned.

On 27 December, Beckmann leaves his apartment to go to the Metropolitan Museum of Modern Art, where his *Self-Portrait in Blue Jacket* is being shown in the exhibition 'American Painting Today'. He collapses and dies of a heart attack at the corner of 61st Street and Central Park West.

Beckmann in Central Park, New York, 1950

Endnotes

1 Phrase coined by Beckmann in 1916. Cited in Doris Schmidt, "Biography", in *Max Beckmann: A Retrospective*, ed. by Carla Schulz-Hoffmann and Judith C. Weiss, exh. cat. (Munich, 1984), p. 174 (hereafter *Retrospective*).

2 Speech given by Max Beckmann at Washington University, St Louis, 23 September 1947; in Mathilde Q. Beckmann, *Mein Leben mit Max Beckmann*, pp. 198ff. Translation in Walter Barker, "Beckmann as Teacher: An Extension of His Art", *Retrospective*, p. 174.

3 Beckmann to Lackner, 19 January 1938. Translation in Stephan Lackner, "Exile in Amsterdam and Paris 1937–47", *Retrospective*, p. 146.

4 Diary entry of 2 Mai 1941. Translation in Cornelia Stabenow, "Metaphors of Helplessness: The Sculpture of Max Beckmann", *Retrospective*, p. 141.

5 *Almanac 1904–1924*, (Munich: R. Piper and Co., 1923) p. 82. Translation in *Retrospective*, p. 310.

6 Beckmann, "Schöpferische Konfession", in *Tribüne der Kunst und Zeit XIII*, ed. Kasimir Edschmid, (Berlin 1920) p. 63f. Translation in Wolf-Dieter Dube, "On the 'Resurrection'", *Retrospective*, p. 81.

7 Diary entry of 28 January 1901. Translation in *Retrospective*, p. 193.

8 Max Beckmann, *Briefe im Kriege*, ed. Minna Tube, Berlin, 1916, pp. 58ff. Translation in Charles Werner Haxthausen, "Beckmann and the First World War", *Retrospective*, pp. 73ff.

9 Beckmann in the third of his "Letters to a Woman Painter", *College Art Journal* 9, 149. Cited in Peter Beckmann, "Beckmann's Path to His Freedom", *Retrospective*, p. 11.

10 Diary entry of 3 October 1914. Translation in *Retrospective*, p. 200.

11 Max Beckmann, "On My Painting", (lecture originally delivered as "Meine Theorie in der Malerei") given at the New Burlington Gallery, London, 21 July 1938. English translation in Herschel B. Chipp, Peter Selz and Joshua C. Taylor, *Theories of Modern Art*, University of California Press, Berkeley and Los Angeles, 1968, p. 188. Cited in Peter Selz "The Years in America", *Retrospective*, p. 164.

12 Beckmann, "Letters to a Woman Painter", in Peter Selz, *Max Beckmann*, New York, Museum of Modern Art, 1964, p. 132. Cited in Selz, *Retrospective*, p. 165.

13 Diary entry of 4 July 1946. Translation Carla Schulz-Hoffmann, "Bars, Fetters, and Masks: The Problem of Constraint in the Work of Max Beckmann", *Retrospective*, p. 47.

14 Beckmann, "Schöpferische Konfession". Translation in Dube, *Retrospective*, p. 81.

15 Beckmann to Curt Valentin, 11 February 1938. Cited in Schmidt, *Retrospecitve*, p. 460.

16 Max Beckmann to Peter Beckmann, 27 August 1948. Cited in Schulz-Hoffmann, *Retrospective*, p. 15.

17 Beckmann, unpublished letter to Valentin, 11 February 1938. Cited in Selz, *Max Beckmann*, p. 61.

18 Diary entry of 28 October 1944. Translation in Stabenow, *Retrospective*, p. 141.

19 Beckmann, "On My Painting", p. 188. Cited in Selz, *Retrospective*, p. 164.

20 Diary entry of 17 September 1948. Translation in Lackner, *Retrospective*, p. 157.

21 Diary entry of late July 1944. Translation in Schmidt, *Retrospective*, p. 465.

22 Diary entry of 9 February 1949. Translation in *Retrospective*, p. 308.

23 Beckmann in Reinhard Piper, *Nachmittag: Erinnerungen eines Verlegers*, (Munich, 1950) p. 30. Translation in Schulz-Hoffmann, *Retrospective*, p. 16.

24 Diary entry of 4 May 1940, in Beckmann, *Tagebücher 1940–1950*, (Munich, 1979) p. 72. Translation in Schulz-Hoffmann, *Retrospective*, p. 20, note 18.

25 Beckmann, *Tagebücher 1940–1950*, p. 72. Translation in Schulz-Hoffmann, *Retrospective*, p. 52.

26 Beckmann, "On My Painting", published in English translation by Buchholz Gallery, Valentin, New York, 1941. Cited in Peter Eikenmeier, "Beckmann and Rembrandt", *Retrospective*, pp. 121–22.

27 Diary entry of 17 January 1949. Translation in Schmidt, *Retrospective*, p. 470.

28 Mathilde Q. Beckmann, in *Beckmann*, Catherine Viviano Gallery, New York, 1964. Cited in Selz, *Retrospecitve*, p. 168.

29 Beckmann, "On My Painting", in Mathilde Q. Beckmann, *Mein Leben mit Max Beckmann*, 1983, p. 190. Translation in Sarah O'Brien-Twohig, "Beckmann and the City", *Retrospective*, p. 98.

30 W. R. Valentiner, "Max Beckmann", in *Blick auf Beckmann: Dokumente und Vorträge*, Hans Martin von Erffa and Erhard Göpel, eds., (Munich, 1962) p. 85. Cited in Selz, *Retrospective*, p. 163.

31 Mathilde Q. Beckmann in interview with Peter Selz, New York, April 1964. Cited in Selz, *Retrospective*, p. 163.

32 Beckmann, "On My Painting", p. 187. Cited in Selz, *Retrospective*, p. 167.

33 Beckmann, *Briefe im Kriege*, (Munich, 1955) pp. 34–35. Translation in Schmidt, *Retrospective*, p. 448.

List of Illustrations

Listed according to page number. Where illustrated more than once,
the italicized number refers to the picture in full.

117

Selected Bibliography

Writings by Beckmann

Leben in Berlin; Tagebücher 1908–1909, 1912–1913, ed. by Hans Kinkel. Munich: 1966; 1983.

"Gedanken über zeitgemässe und unzeitgemässe Kunst". *Pan 2* (March 1912) pp. 499ff.

Briefe im Kriege, collected by Minna Tube. Berlin, 1916; 2nd ed. Munich: 1955.

On My Painting. New York: Buchholz Gallery, Curt Valentin, 1941.

Tagebücher 1940–1950, compiled by Mathilde Q. Beckmann, ed. by Erhard Göpel. Munich: 1955, 1979.

Speech given by Beckmann to his first class in the United States at Washington University, St Louis, 23 September 1947 (in *Mein Leben mit Max Beckmann*, by Mathilde Q. Beckmann, pp. 198ff.)

"Letters to a Woman Painter". *College Art Journal* 9 (Autumn 1949): pp. 39ff.

Exhibition Catalogues

London, 1938, New Burlington Galleries, *Exhibition of 20th Century German Art.*

New York, 1946, Buchholz Gallery, Curt Valentin, *Beckmann: His Recent Works from 1939–1945.*

Munich, 1951, Haus der Kunst, *Max Beckmann zum Gedächtnis 1884–1951.*

New York, 1964, The Museum of Modern Art, *Max Beckmann.*

New York, 1973, Catherine Viviano Gallery, *A Catalogue of Paintings, Sculptures, Drawings & Watercolors by Max Beckmann.*

Munich, Berlin, St Louis, and Los Angeles, 1984, Haus der Kunst, Nationalgalerie, The Saint Louis Art Museum, Los Angeles County Museum of Art, *Max Beckmann: Retrospective.*

Books and Articles

Beckmann, Mathilde Q. *Mein Leben mit Max Beckmann.* Translated from the English by Doris Schmidt. Munich: 1983.

Beckmann, Peter. *Max Beckmann.* Nürnberg, 1955.

—, ed. *Max Beckmann: Sichtbares und Unsichtbares.* Stuttgart: 1965.

Selz, Peter. *German Expressionist Painting.* Berkeley: 1957.

Zenser, Hildegard. *Max Beckmanns Selbstbildnisse,* Dissertation. Munich: 1981.

Photo Credits

Alinari, Florence: page 20

Felicia Feith: page 106

Helga Fietz: pages 108, 109

Jeanne Kaumann: page 105

Hugo Kuhn: page 108

Stedelijk Museum, Amsterdam: page 64

The Saint Louis Art Museum, St Louis: pages 55, 79

All other illustrations from the Prestel archive

Front cover and spine: *Self-Portrait in Front of Red Curtain*, 1923,
private collection, courtesy Neue Galerie New York
Frontispiece: *Self-Portrait in Florence*, 1907 (detail; see page 19)
Page 4: *Self-Portrait with Crystal Ball*, 1936

The Library of Congress Cataloguing-in-Publication data is available.
The Deutsche Bibliothek holds a record of this publication in the
Deutsche Nationalbibliografe; detailed bibliographical data can be
found under: http://dnb.ddb.de

© Prestel Verlag, Munich · Berlin · London · New York 2003
(frst published in hardback in 1997)
© of works illustrated by Max Beckmann, by VG Bild-Kunst,
Bonn 2003

Prestel Verlag
Königinstrasse 9, 80539 Munich
Tel. +49 (89) 38 17 09-0
Fax +49 (89) 38 17 09-35

Prestel Publishing Ltd.
4 Bloomsbury Place, London WC1A 2QA
Tel. +44 (020) 7323-5004
Fax +44 (020) 7636-8004

Prestel Publishing
175 Fifth Avenue, Suite 402,
New York, NY 10010
Tel. +1 (212) 995-2720
Fax +1 (212) 995-2733

www.prestel.com

Manuscript edited by Andrea P.A. Belloli, London

Designed by Karin Mayer
Cover designed by Matthias Hauer
Typeset by Reinhard Amann, Aichstetten
Originations by Eurocrom 4, Villorba (TV), Italy
Printed by Passavia Druckservice GmbH., Passau
Bound by Conzella, Pfarrkirchen

Printed in Germany on acid-free paper

ISBN 3-7913-2877-8 (paperback)
ISBN 3-7913-1737-7 (hardback)